IMAGES of America
OAKDALE
THE LAPEER STATE HOME

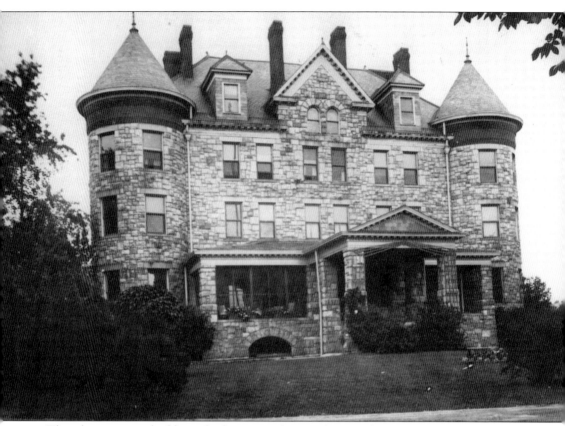

The administration building, also known as the "Castle," was the most recognizable building on the campus of the Lapeer State Home. Built with local materials, the Castle housed the early medical directors and their families, offices for physicians, meeting and storage rooms, and office space for support-staff members. (Courtesy of the Leroy Mabery collection.)

ON THE COVER: Two workers arrive for their shift in the 1940s at the home's dining hall, which is first mentioned in the Lapeer State Home's 1900 biennial report. Residents and staff were fed by the kitchen, which was stocked with meat, dairy, and produce from the home's own farm. A separate bakery provided fresh breads, pastries, and desserts daily. (Courtesy of the Leroy Barnett Collection of the Bentley Historical Library, University of Michigan.)

IMAGES of America
OAKDALE
THE LAPEER STATE HOME

Laura Fromwiller and Jan Gillis

Copyright © 2014 by Laura Fromwiller and Jan Gillis
ISBN 978-1-4671-1243-7

Published by Arcadia Publishing
Charleston, South Carolina

Printed in the United States of America

Library of Congress Control Number: 2014941769

For all general information, please contact Arcadia Publishing:
Telephone 843-853-2070
Fax 843-853-0044
E-mail sales@arcadiapublishing.com
For customer service and orders:
Toll-Free 1-888-313-2665

Visit us on the Internet at www.arcadiapublishing.com

This book is dedicated to all the residents of the Lapeer State Home who felt alone and forgotten, as well as the dedicated staff who loved and cared for them.

Contents

Acknowledgments		6
Introduction		7
1.	The Beginning: 1893–1900	9
2.	The Medical Superintendents	21
3.	The Staff and Residents	35
4.	The Facilities	51
5.	The Farm	79
6.	The Community	85
7.	Controversy	93
8.	Decline and Closure	103

Acknowledgments

Lapeer is a city that values its history. Those who live, or lived, here are proud of their heritage and generous with their knowledge and materials. We are grateful to all the Lapeer-area community members who shared their stories and memories with us. This publication would not have been possible without the collaboration and generosity of many individuals, including Joann Ethridge, who provided scrapbooks of her husband's tenure with the Lapeer State Home; Leroy and Hazel Mabery, who shared their collection of postcards and photographs; Jan Reithel, who provided newspaper clippings, photographs, and Oakdale staff newsletters; Jane P. Lewis, who provided family photographs of the DesNoyer family; Don McCallum, who provided photographs and postcards; Gloria Michelson, who provided staff newsletters, photographs, and staff information; Charlie Whipp, who provided photographs; and Joan Scott, who provided information about the Lapeer Parents Association for Retarded Children.

Those whose time and dedication providing hours of research include Katie Rothley, Sarah Raymond, Ellen Williams, Ashley Armstrong, and the staffs of the Lapeer District Library, the Grand Rapids Public Library, and the Grand Rapids Public Museum. As a result of their efforts, the facts in this publication are as authoritative as possible.

We would like to also thank the Library of Michigan, Michigan State University, and Michigan Technological University for loaning to us the early biennial reports from which several photographs were used in this publication.

The Marguerite deAngeli Branch of the Lapeer District Library (LDL), Jeffrey Hogan from the *County Press* newspaper, and the Bentley Historical Library at the University of Michigan also provided important research materials and photographs.

We are also grateful to the Arcadia editors and staff for their patience, encouragement, and guidance.

Finally, we would like to thank all those who listened to us report excitedly on our findings, put up with our obsession about research and locating materials, and in other ways supported us on this venture, including our families, coworkers, and friends.

Introduction

Oakdale, the Lapeer State Home (the home), opened in 1895 as the Michigan Home for the Feeble Minded and Epileptic. It has changed names many times over the years, and was also known as the Michigan Home and Training School, Lapeer State Home and Training School, and the Oakdale Center for Developmental Disabilities. The ongoing goal of the institution was to create a homelike atmosphere for those who could not adjust to normal community life because of their mental or physical deficiencies. Originally opening with beds for 200 residents, the facility had a difficult time keeping up with demand, continuously fought overcrowding issues, and eventually grew to house over 4,000 patients by 1945.

The home was one of the most respected facilities of its kind in the United States and was considered to have some of the best medical staff and medical facilities in the state. Early admissions were limited to children, and the ideal age was thought to be 6 to 18, so a child could be taught and could become a contributing member of the home community, where they generally remained for the duration of their lives. By the time the home closed, the administration only admitted those who required constant care and were severely disabled.

Oakdale operated on a developmental model that believed in teaching and training the residents in hopes of returning them to community living whenever possible. Educational classes were held for residents daily and included the traditional math, reading, and science, but also provided classes on vocational skills such as furniture making, basket weaving, cooking, and laundry. These additional classes provided skills for residents to contribute to the daily needs of the home, as well as provide them skills they could use in the community to become productive members of society. The home also had a very successful farm that had housing for male residents who worked and learned about daily life on a farm. The home farm provided meat, produce, and dairy for the home's kitchen and taught valuable skills to the residents.

The home was considered a city within itself. All of the resident and staff needs could be met without ever leaving the campus. Housing, a dining hall, hospital, dentist office, cobbler shop, print shop, general store, school, park, barbershop, blacksmith, laundry and sewing facility, post office, chapel, gymnasium, bakery, powerhouse, library, pharmacy, cemetery, and many storage and farm buildings were on-site. All of the clothing, food, power, shoes, towels, and even mattresses were made by the staff and residents of the home.

The home employed thousands of Lapeer citizens over the years, many were related, and it was not unusual for multiple generations to work together. Most had the best interest of the residents at heart, but as with any employment of this nature, unfortunately, there were occasionally those who were unkind. The staff at the home made impressive strides, especially in teaching, creating the first special-education program in the state and training other teachers from this model. The medical superintendents who led the home were some of the most highly respected medical professionals in the country. They spearheaded medical and educational opportunities for the residents and staff of the home that they may never have had without the persistence

and foresight of these professionals. The base of the care residents received lay with the everyday attendants, cooks, and caretakers. This work was generally not easy and took a kind and patient demeanor. Many of these caretakers went above and beyond what was expected in their job descriptions. Residents were often brought to the caretaker's home for dinner, taken shopping, read to, sung to, and cared for with love. It was not just a job for many; those who did this work truly cared for these individuals.

Daily life in the home was a good balance of work, education, and fun. Holidays were honored, dances were held, music was played and sung by all, and birthdays were celebrated. Many events, such as plays and musical shows, were open to the residents, families, and the community, making the home a valuable part of Lapeer.

Controversy was always prevalent at the home. Medical decisions that seemed cutting-edge and in the residents' best interest at the time were later found to be extremely controversial and lacked moral judgment. The home had its share of runaways, pregnancies, assaults against patients, assaults against staff, and even murders. There were many questions pertaining to who should be housed at the home, how long residents should stay, and where they should go when they leave. The daily work that residents did to keep them productive and give them skills and a sense of belonging eventually was seen as unfair labor and banned by the state, leaving staff overworked and residents with too much time on their hands. Some were eventually sent out to work in the community, which caused some additional concerns and controversy.

Society's ideas of the best way to care for residents changed, but the home was slow to follow. The campus buildings did not conform to new standards and required substantial remodeling in order to properly service the handicapped residents. New state guidelines for resident treatment required additional staff, which in turn required additional expenditures. The home struggled to meet these new standards, and as residents of the home were transferred to group homes that were cheaper to run than large institutions and promised to provide a better quality of living for residents, the home began to lose funding and credibility. The buildings fell into disrepair, and the facility began a steep decline until eventually it was forced to close.

Upon its closure, the property and buildings of Oakdale were purchased in 1992 by the City of Lapeer for $1, with the stipulation that it could only be used for governmental or educational purposes. From 1993 until 2001, the city undertook a $538,000 project to demolish the campus. Today, only memories remain of the old Lapeer State Home. Physically, the cemetery and three repurposed buildings still stand. These buildings include the Chatfield Charter School, Mott Community College, and Lapeer Community School's Rolland-Warner Middle School.

One
THE BEGINNING
1893–1900

In the 1800s, psychiatrists believed that the progress of civilization and technology was harmful to people's overall mental health and that asylums were the best way to treat the mental illnesses of a modern society. In the United States, three states had their own public mental hospitals by 1840. By 1880, the United States had 1,410 public and private mental hospitals with 41,000 patients. As public officials transferred people with mental disabilities from jails and local workhouses to nearby asylums, they became overcrowded. Asylums were also filled with aged and chronically ill patients as families increasingly petitioned for the hospitalization of elderly relatives. By 1893, Michigan already had several mental asylums and hospitals and a number of training schools. Still, the Michigan government struggled to meet the growing need for mental health care. The history of Oakdale has its beginnings with a Lapeer resident and the name the "Lapeer Home for the Feeble Minded and Epileptic."

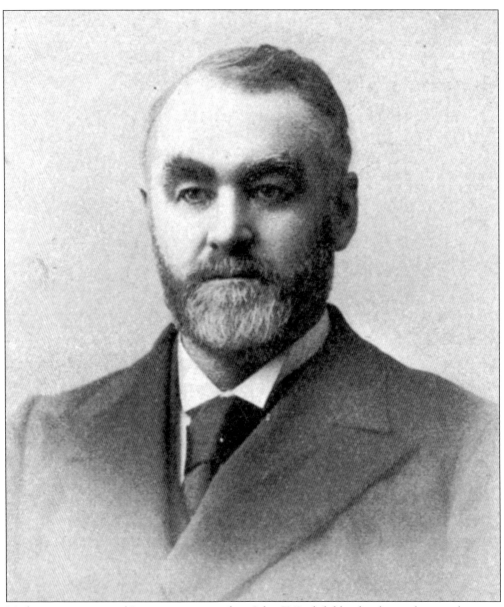
Michigan governor and Lapeer county resident John T. Rich lobbied to bring the state home to Lapeer. When the bill to create the home passed on June 2, 1893, several locations were taken into account, but the city of Lapeer was chosen when city councilmen donated 160 acres and agreed to supply free water for five years. Farmers Creek was to be used for sewage disposal, but when a nearby property owner objected, the city put in a sewer line to the home. A budget of $50,000 was established for the 200-bed facility. This portrait of Rich is from his 1895 "Inaugural Program." (Courtesy of LDL.)

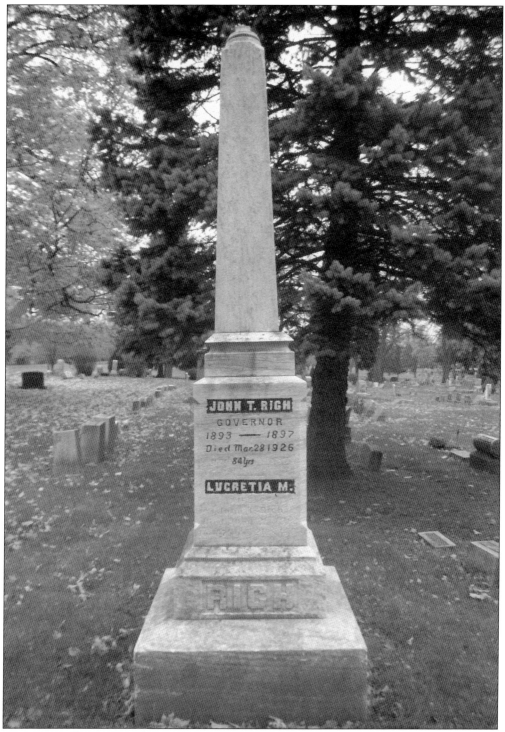

Governor Rich was a member of the building committee and would remain on the committee even after he was no longer governor. He is buried in Mt. Hope Cemetery in Lapeer. (Courtesy of LDL.)

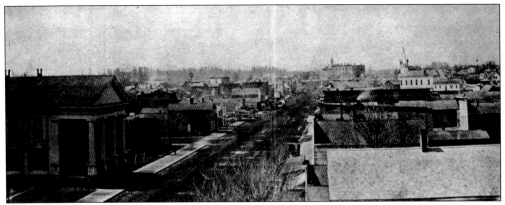

The cornerstone for Cottage A (Building 18) was laid on June 26, 1894, with Masonic rites and a full parade down Nipissing Street (now West Nepessing Street), shown in this c. 1900 photograph. According to the paper, the crowd in attendance was over 50,000, with prominent people, including Rich, from all over the state. A box placed in the cornerstone held information about Lapeer in 1894. (Courtesy of LDL.)

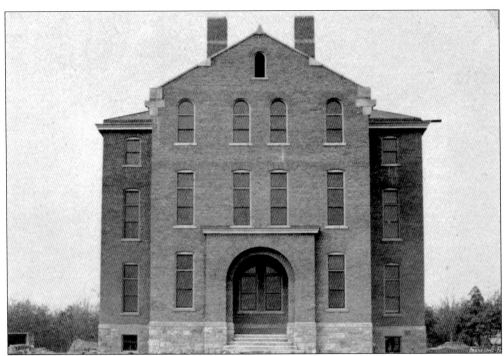

Swiss-born Julius Hess (1841–1899) was chosen to design the first four buildings. He designed several Detroit buildings that are in the National Register of Historic Places, including the Grand Army of the Republic Hall, the St. John's–St. Luke's Evangelical Church, and several others. Cottage B (Building 19) designed by Hess is shown here. (Courtesy of the Leroy Mabery collection.)

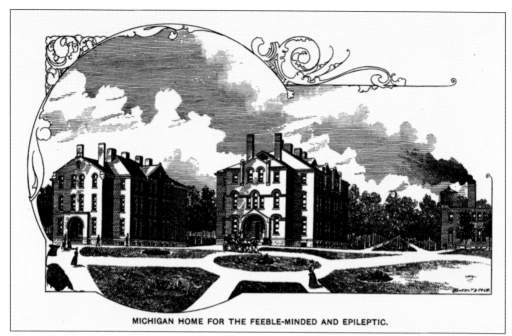

MICHIGAN HOME FOR THE FEEBLE-MINDED AND EPILEPTIC.

From the beginning, the home was unable to accommodate the number of patients waiting for admission. Only 200 of more than 800 applicants were accepted. The first superintendent, Dr. William A. Polglase, wrote that the design of the initial cottages was inadequate to house epileptics or the feebleminded, so only those children who might improve and could get to and from the dining hall were admitted. Most of the residents initially admitted were between the ages of 8 and 18. This engraving of Cottages B (housing 100 feebleminded males) and A (housing 100 feebleminded females) and the dining hall is printed in the home's first biennial report. The home would grow rapidly to accommodate more residents. This postcard dated 1898 shows, from left to right, Cottages C, B, A, the dining hall, and Cottage D. (Below, courtesy of the Leroy Mabery collection.)

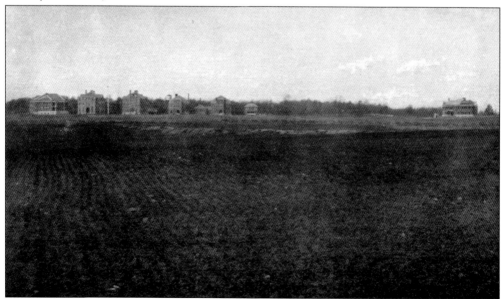

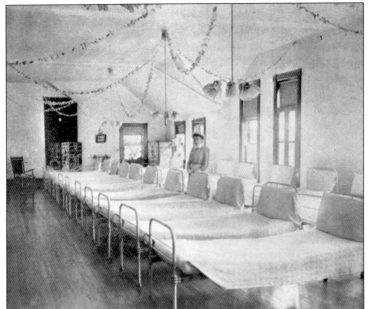

The home officially opened on August 1, 1895. Jennie (Ethel Anne) Carter was the first resident admitted. The cottages each had a schoolroom, a common room, and dormitories to house 100 residents. Each home attendant cared for 25 residents. The schoolrooms were too small to serve all of the students, so classes ran a half day. Attendant Anna Allen poses in this photograph of a dormitory room in Cottage A from the home's biennial report.

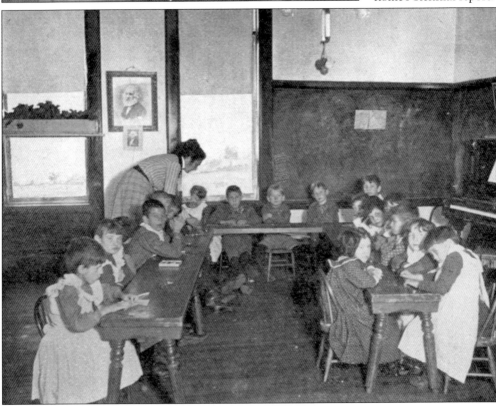

The first classes started on September 11, 1895, with 23 pupils and by June 1896 had grown to 113 pupils. There were five teachers. About half of the home's 45 employees worked with the residents, and there was one employee for every 4.7 residents. Shown here is a kindergarten class that appears in the home's 1898 biennial report.

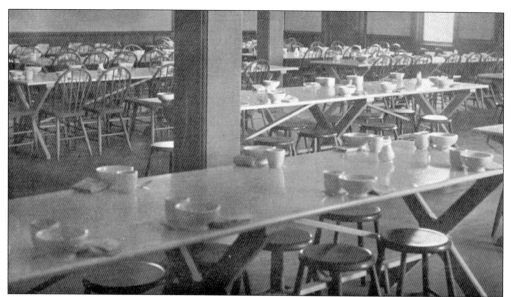

There was no room to house employees in the cottages, so they were boarded in the top floor of the dining hall, which was also used for storage and clothes making. The basement of the dining hall was used for the bakeshop, storage, machining, and carpentry. This image from the home's 1898 biennial report shows the dining hall set up for service.

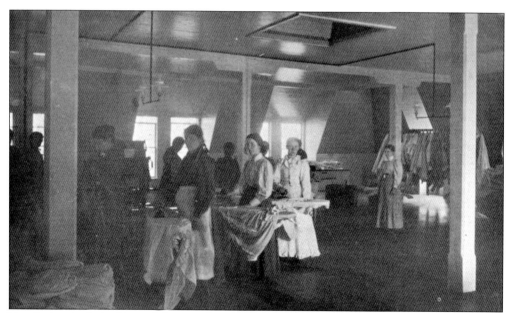

Ventilation in the buildings did not work properly, and none of the residents had been quarantined on arrival, so Polglase believed these conditions were making the residents and staff sick. Because the cottages were so crowded, windows had to be left open even when it was cold outside. The laundry was housed in the boiler room. This 1898 photograph from the biennial report shows the conditions in the laundry room.

During the first winter at the home, there was a chicken pox outbreak and a diphtheria outbreak (the latter caused the death of a resident and a teacher). The upper floor of one of the cottages was converted into a makeshift hospital, and eventually a small building was rented to segregate the sick. By 1900, the home had a small hospital. This photograph of the hospital is from the 1904 biennial report.

By June 1896, the home was in "fine" health, and church was being held outside in its "fine grove" when the weather was nice; services were usually held in the dining hall. This 1910 biennial report image shows some early landscaping at the home. Residents were also making the most of their clothing, but the home wanted to add more industries to teach and employ them.

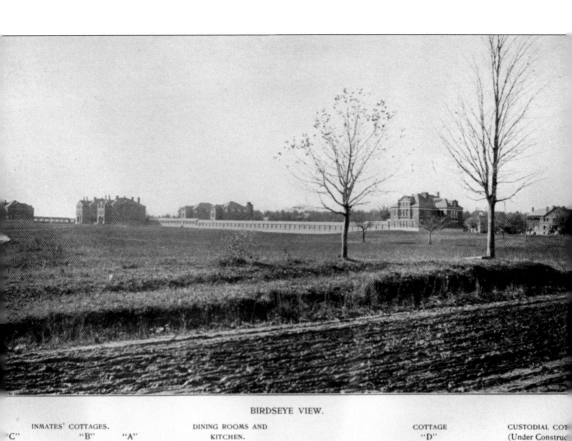

BIRDSEYE VIEW.

INMATES' COTTAGES.			DINING ROOMS AND KITCHEN.	COTTAGE	CUSTODIAL COT
"C"	"B"	"A"		"D"	(Under Construc

Polglase reported that there was no money for landscaping, so residents were used for grounds maintenance. He also felt walkways were needed for residents to exercise when the weather was bad. Construction would begin for covered walkways in 1898–1899 to connect, from left to right, Cottages C, B, A, the dining hall, and Cottage D. Partially constructed Cottage E is also shown here, on the far right, from the 1900 biennial report.

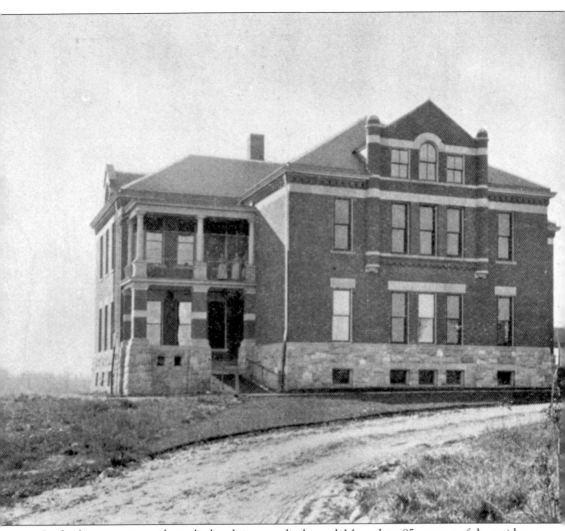

In the first year, six residents died and six were discharged. More than 85 percent of the residents were supported by the state. In the first year, $37,000 was spent, with $50,000 estimated for expenses for the second year. Dr. Polglase requested $152,000 from the state for six cottages, outbuildings, and 160 acres of land. Cottage C housed 75 female epileptics and is shown here from a biennial report. It opened in 1897.

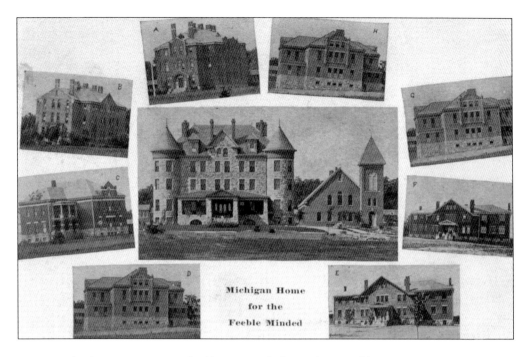

By 1900, the home encompassed 355 acres, including 35 acres of lawn, 23 acres of grove, and the rest in gardens and pastureland. There were five resident cottages: A, B, and C were in use, and D and E would be completed in 1901. Cottage D housed 75 male epileptics, and Cottage E housed 150 custodial cases (residents who required constant care). The campus also had a hospital, two dining halls (one for males and one for females), a kitchen, a laundry facility, stables, and a powerhouse. The 1,100 feet of covered walkways that connected the group of buildings had a utility tunnel underneath where the steam mains ran for heating the buildings. The interior of one of the walkways is shown below from the 1912 biennial report. Cottages F and H seen in postcard above were completed in 1906. (Above, courtesy of the Leroy Mabery collection.)

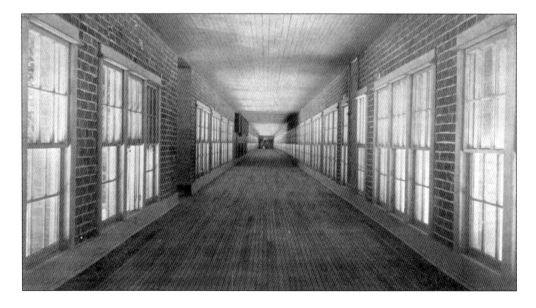

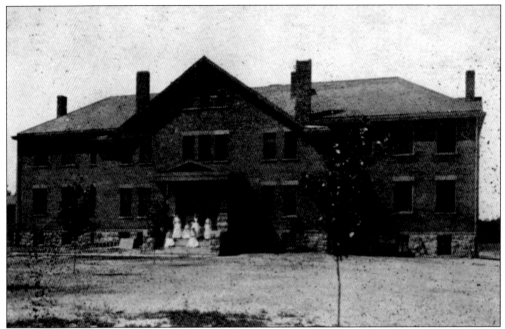
Architect Edwyn Albert Bowd (1865–1940) of Lansing became the home's main architect in 1900. Bowd was involved in the design of 10 buildings in the National Register of Historic Places in Ingham County alone. The first building he designed for the home was Cottage E. The same design was used for Cottage F, pictured here in the 1912 biennial report.

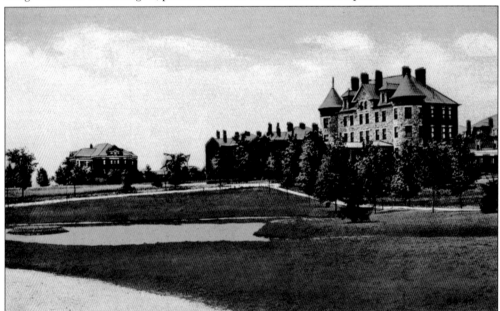
There was no office to admit new residents or for administration personnel to work, so Dr. Polglase requested funds to build an administration building and a chapel. Construction of the "Castle" and the chapel buildings began in 1901. The view in this postcard looks south and shows the Castle and, from left to right, the dining hall and Cottages A, B, and C. (Courtesy of the Leroy Mabery collection.)

Two

THE MEDICAL SUPERINTENDENTS

In the 97-year history of the Lapeer State Home, there were 12 medical superintendents. The medical superintendent of a state facility was considered a highly prestigious position held only by those most qualified and carefully screened by the State of Michigan. In the early days of the home, the medical superintendent was appointed by the governor of Michigan. All of the superintendents—except one, Albert Meuli—held medical degrees. They were responsible for the day-to-day operation of the home, finances, staff, and reporting to the state on a regular basis.

Three of the medical superintendents died while in service at the Lapeer Home: Dr. William Kay, Dr. Fred Hanna, and Dr. Adolph Rehn. Others went on to fill highly respected positions in the state of Michigan as well as other states. The medical superintendents of the Lapeer State Home each brought his own experience and ideas to the organization; some were motivated to provide work skills to the residents, while some were more interested in the medical aspects and care of the residents.

Each of these superintendents contributed significantly to the structure of Lapeer State Home. Each petitioned the state for funding to add buildings to the campus, expand the farm, provide additional education or medical care and facilities, and improve overall conditions for the residents. Partnerships brought about by the superintendents, including the Parents Association and the parole program, provided residents with advocates and ties with the community in which they lived.

The position that the first medical superintendent held was drastically different than the last. The first was the only doctor at the home and able to truly care for residents and improve their quality of life personally. Toward the end of the Lapeer State Home's existence, the medical superintendents fought red tape and staff negotiations to keep the facility funded and operational with less and less money from the state, lower-functioning residents, less staff, and old buildings. They were unable to spend much time with the residents they were medically trained to care for.

Dr. William Polglase was born in Michigan on March 8, 1856, and attended Detroit Public Schools. He graduated from Chicago Homeopathic Medical College in 1878 and was an active member in the National Association for Study of Epilepsy. Polglase taught at the University of Michigan between 1899 and 1900 as a nonresident lecturer on the theory and practice of medicine as well as on nervous diseases. He served as the medical superintendent of the Lapeer State Home from 1895 to 1906 and then went on to become the deputy superintendent of New York's Metropolitan Hospital, Cumberland Street Hospital, and then the Kings County Hospital. He died in New York on May 4, 1915, at age 59 after complications from cancer surgery. (Courtesy of LDL.)

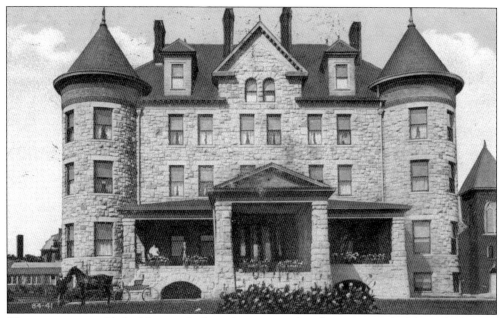

The most recognizable building on the home's campus is the administration building, also known as the Castle, which opened under Polglase's supervision in March 1904. This building also housed the superintendent and his family while in service at the Lapeer State Home. (Courtesy of the Leroy Mabery collection.)

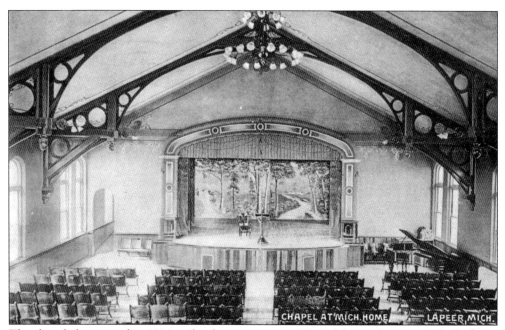

The chapel also opened in 1904 under the supervision of Dr. Polglase, who wanted the home to feel as close as possible to any home and community. The chapel was used for musical programs and plays as well as for religious purposes. (Courtesy of the Leroy Mabery collection.)

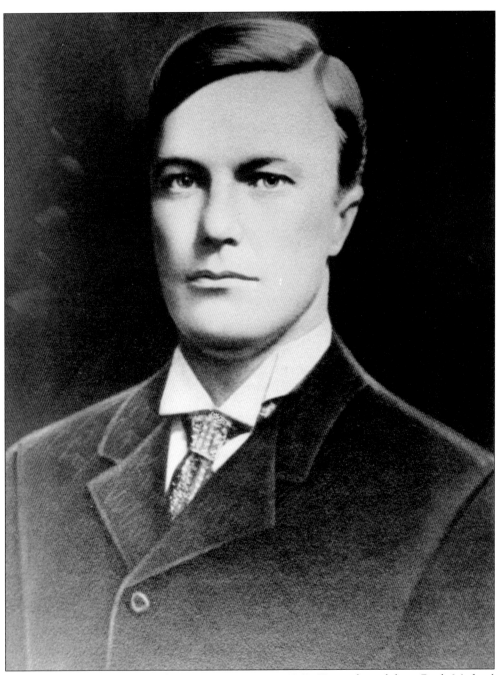
Dr. George Chamberlain was born in Wisconsin in 1869. He graduated from Rush Medical College in 1891. He became assistant superintendent at the Hospital for the Insane in Newbury, Michigan, where he served from 1895 to 1899, before advancing to medical superintendent until 1905. He became medical superintendent in Lapeer from 1907 to 1912. Dr. Chamberlain died in California in 1946. (Courtesy of LDL.)

Dr. Chamberlain requested funding and commissioned the construction of an iron fence with stone posts that was built around part of the home's campus, mostly along the property adjacent to the main roads. (Courtesy of the Leroy Mabery collection.)

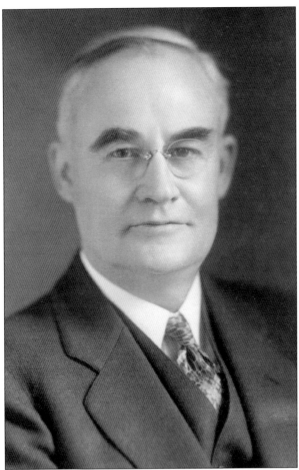

Dr. Harley Haynes was born in Vermont in 1875 and graduated from the University of Michigan in 1902. He was assistant superintendent in Lapeer from 1907 to 1912 and medical superintendent from 1912 to 1924. In 1918, Dr. Haynes applied to the courts for involuntary sterilization of residents. Dr. Haynes later became director of the University Hospital in Ann Arbor, Michigan, from 1924 to 1945. (Courtesy of the Bentley Historical Library, University of Michigan.)

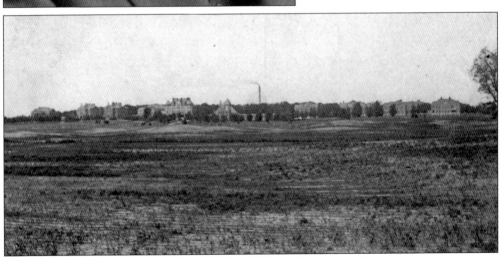

The growing population of the home prompted the solicitation of funds from the state and construction of several new buildings under Dr. Haynes's supervision, including two cottages, a hospital, cow barn, farm cottage, silos, school, and an industrial building. (Courtesy of the Leroy Mabery collection.)

Dr. William Kay was born in Canada in 1867. He graduated from the Detroit College of Medicine in 1897 and opened a practice in downtown Lapeer. He was appointed by Governor Groesbeck as medical superintendent of the Lapeer State Home in 1924, where he served until he died of a throat infection in 1930. (Courtesy of LDL.)

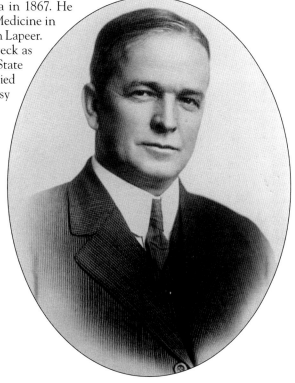

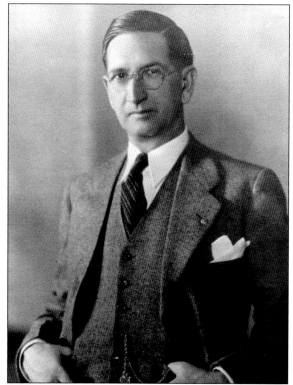

Dr. Robert Dixon graduated from the University of Michigan Medical School and worked for the Michigan Farm Colony for Epileptics in Wahjamega, Michigan. Dr. Dixon was appointed medical director for the Lapeer State Home by Governor Green in 1930 and served until 1937. He went on to become the medical superintendent for the Caro State Hospital. Dr. Dixon died in 1951 in Caro, Michigan. (Courtesy of LDL.)

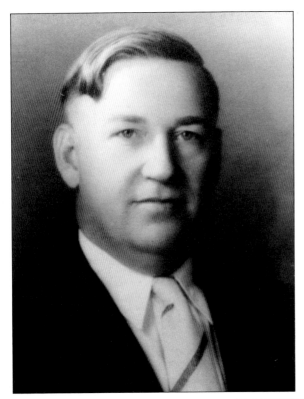

Dr. Fred Hanna was born in Michigan in 1900 and received his medical degree from Wayne State University. In 1933, he joined the medical staff of the Lapeer State Home. He later became the assistant medical superintendent, then medical superintendent in 1937, serving until his death in 1942. While Dr. Hannah was superintendent, the Lapeer State Home was the largest institution of its kind in the world. (Courtesy of LDL.)

Dr. Randall Cooper graduated from the University of Minnesota Medical School and served as the assistant superintendent of the Wichita Falls State Hospital in Texas before becoming the medical superintendent for the Lapeer State Home in 1943. Cooper served until 1947 before going on to be the assistant superintendent in Ionia, Michigan. (Courtesy of LDL.)

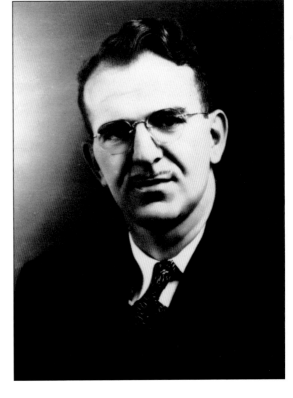

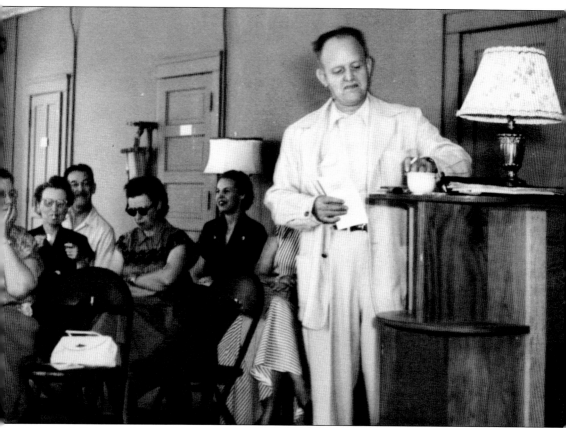

Dr. Adolph Rehn was born in Michigan in 1907. He graduated from Wayne State Medical School in 1934 and worked for the state hospital in Newberry, Michigan, from 1934 to 1938. He became the assistant superintendent at the Lapeer State Home from 1939 to 1941 and then returned to Newberry. In 1943, he became Lapeer's assistant superintendent. He was promoted to medical superintendent in 1947 and served until his death in 1960. (Courtesy of LDL.)

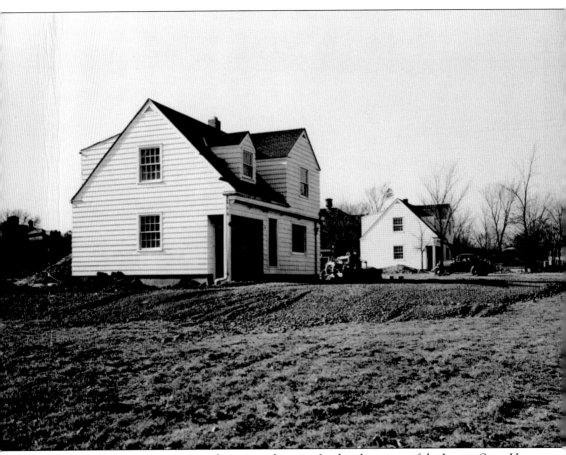

These buildings were constructed as private housing for the physicians of the Lapeer State Home. Dr. Rehn applied for and received the funding from the state, and construction took place between 1957 and 1962. (Courtesy of the Leroy Barnett Photograph Collection, Bentley Historical Library, University of Michigan.)

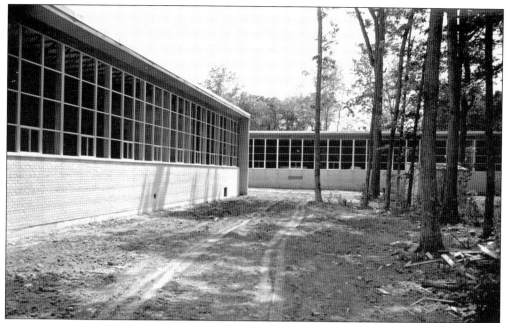

Dr. Rehn believed the residents' education was very important and solicited funding from the state to build a school that held classrooms as well as vocational shops for skill building, such as woodworking and cooking. This school was built around 1955. (Courtesy of the Leroy Barnett Photograph Collection, Bentley Historical Library, University of Michigan.)

This photograph shows the gymnasium inside the Lapeer State Home's School in 1955. The building is still used today as the Lapeer Community Schools Rolland–Warner Middle School. (Courtesy of the Leroy Barnett Photograph Collection, Bentley Historical Library, University of Michigan.)

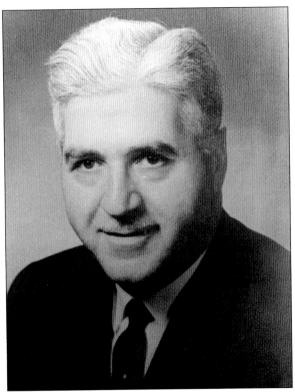

Dr. Anthony Abruzzo was born in Brooklyn, New York, on October 9, 1911. He received his doctorate in psychiatry from Loyola University and served as the assistant supervisor for Wayne County General Hospital and the Wayne County Training School for the Retarded before becoming medical superintendent for the Lapeer State home in 1960. (Courtesy of LDL.)

Dr. Anthony Abruzzo was well respected by the residents and staff of the Lapeer State Home and retired in 1972. He stayed in Lapeer until his death on April 20, 1986. He is buried in Lapeer's Mount Loretto Cemetery. (Courtesy of LDL.)

Albert Meuli was born in 1925 and received his master's in hospital recreation from the University of Minnesota and a master's in public administration from the University of Washington. Meuli was assistant director of Washington State's Social Services Department from 1961 to 1972 and then served as Lapeer Home's medical superintendent from 1972 to 1975. In 1978, he became the director of Newberry Regional Mental Health in Michigan, serving until his death in 1986. (Courtesy of LDL.)

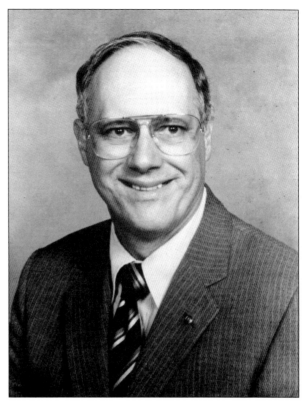

Dr. Joseph Denniston was born in New York in 1914. He graduated from Tufts Medical School and then opened a private practice in Kentucky from 1946 to 1960. Denniston served as medical superintendent for state hospitals in Tennessee, Oklahoma, Indiana, Pennsylvania, and finally Lapeer, from 1975 to 1976. He later became the director of mental health for the state of Michigan. Dr. Denniston died in Florida in 1978. (Courtesy of LDL.)

Dr. David A. Ethridge was born on October 12, 1933, in Canton, Illinois. He graduated from Western Michigan University with an undergraduate degree in occupational therapy and served in the US Air Force as an occupational therapist. He later attended Wayne State University and received his master's degree in vocational rehabilitation. He received his doctorate in guidance and counseling from Michigan State University. Dr. Ethridge became the director of the Ionia State Hospital before becoming the medical director for the Lapeer State Home in 1976. Dr. Ethridge took his position very seriously because had a brother with Down's syndrome who was a resident in a different state institution. Dr. Ethridge served until the facility closed in 1992. He died in Lapeer on June 10, 2013. (Courtesy of LDL.)

Three

THE STAFF AND RESIDENTS

From the beginning, the staff of the Lapeer State Home was made up of caring and dedicated people. The institution quickly gained and maintained the reputation of being a well-run and state-of-the-art facility. People came from all over Michigan to work at the home, which, over time, employed thousands of people; 90 percent from Lapeer County, making it the second-biggest employer in the county behind agriculture. It was not unusual for family members of several generations to work at the home.

The staff not only provided basic care to residents but also a family atmosphere that, in the early years, included many live-in married couples who supervised the cottages. Holidays were celebrated with Easter egg coloring, Christmas parties, special meals, and Fourth of July parades and picnics with treats like ice cream and ginger ale. Residents planted trees for Arbor Day, birthdays were celebrated monthly, and movies were shown on the weekends. One year, for Memorial Day, two teachers made an 11-foot flag to be flown at the home. Staff dances were held, and many staff romances bloomed into marriage. Dances were also held for the residents, alternating weeks between boys and girls.

Originally providing housing and care for epileptics, the home moved the epileptic patients to the hospital in Caro, Michigan, in 1913. This was done in order to focus more attention on teaching and training residents in hopes that they would eventually become productive members of society. By 1922, all residents were admitted only by order of probate court; this included mentally deficient and handicapped children, orphans, abandoned children, and juvenile delinquents, and special consideration was given to the poor. The home never accepted insane or criminally insane residents.

The residents, who came from every county in Michigan, added to this family atmosphere. Many helped to take care of the home and each other and became very close during their long-term stays. The older residents helped to care for the younger, and bonds were created—not unlike siblings.

Benjamin Franklin "Frank" DesNoyer was born in Port Huron, Michigan, in 1868. With his practical experience in steam engineering, he became the first chief engineer of the home after it opened in 1897. He later conceived the idea of a home fire department, so a truck was purchased, and home mechanics equipped it with extension ladders, 750 feet of hose, and chemical tanks for electrical fires. (Courtesy of Jane Lewis.)

Frank DesNoyer was present at the cornerstone-laying ceremony of the Lapeer State Home on June 26, 1894, and he worked for the State of Michigan for 48 years. He was a highly respected engineer in the state and made much progress for the Lapeer State Home. Desnoyer died in Lapeer on February 9, 1942, at the age of 73. (Courtesy of Jane Lewis.)

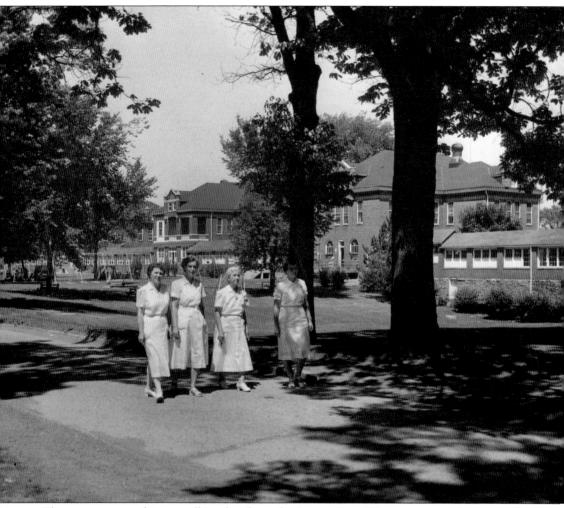

These nurses are taking a walking break on the Lapeer State Home campus. The nursery had 72 employees and housed 190 patients between the ages of 1 and 12 in 1962. These patients were placed in cribs and required round-the-clock, infant-type care. (Courtesy of the Leroy Mabery collection.)

Starched white uniforms were required for all female nurses and attendants. This nurse is Elsie Rowden, known to the residents as "Ma Rowden." She stands in front of one of the cottages, marked Building 39. (Courtesy of Jane Lewis.)

This photograph shows one of the buildings that provided housing for the staff. In the early years of the home, staff members were required to live on campus and were housed in the attics of the original cottages. They were paid a salary and were provided housing, food, and clothing. Later in the home's history, dedicated buildings were constructed to house staff. In the mid-1930s, staff was given the option to stay on or off the grounds. (Courtesy of the Leroy Mabery collection.)

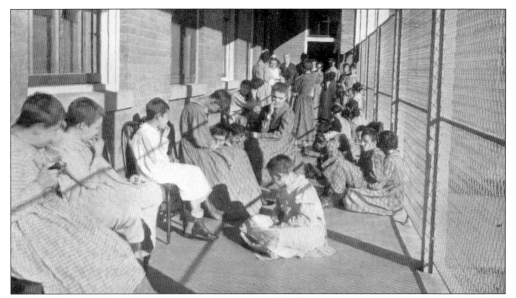

These "unteachable" custodial cases shown in the 1904 biennial report had a mental age of 0–3 or an IQ less than 25 and required infant-type care. Residents with a mental age of 3–7.5 or an IQ of 25–49 could be taught but required constant supervision. A mental age of 7.5–10.2 or an IQ of 50 or over could be unsupervised for short periods of time, taught, and eventually paroled.

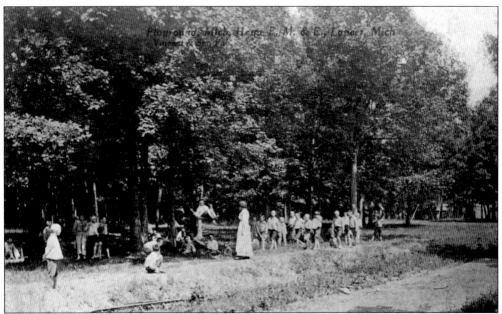

Physical activity and recreation was very important for all residents at the home. Children were often taken for walks on the grounds and played on the playground equipment that was provided by the Parents Association in 1964 along with a riding train and carousel. (Courtesy of the Leroy Mabery collection.)

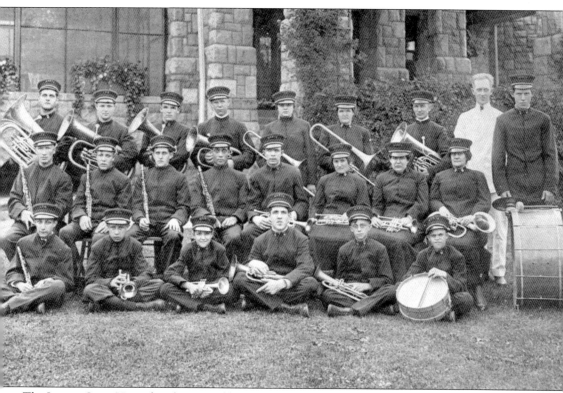

The Lapeer State Home band, pictured here from the 1916 biennial report, is an example of the importance of music as therapy at the home. Residents also participated in a glee club and symphony band. The band also played frequently in community events such as parades and conventions.

These young male residents take a break from their studies and benefit from the fresh air and physical therapy of a walk across the beautiful, well-kept grounds of the home with their attendants. (Courtesy of the Leroy Mabery collection.)

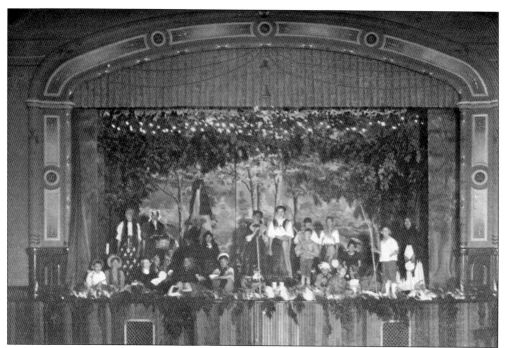

Staff and residents participated in many games and activities on the campus, including baseball games where the medical superintendent served as umpire. In the early 1900s, the staff took residents to Davis Lake for camping, fishing, boating, and swimming. Talent shows were held, and the staff and residents entertained each other and invited the community to attend. This cantata scene is from the 1912 biennial report.

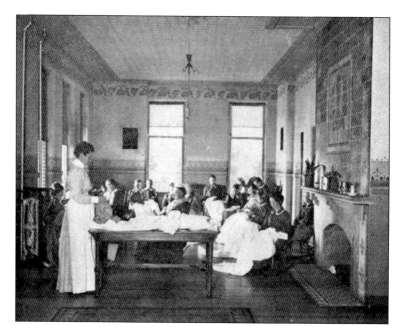

This afternoon scene from the 1900 biennial report shows the women residents practicing their sewing skills while relaxing in Cottage C. A piano was placed in all the female cottages by 1922, and Victrolas and games were in all of the male and female cottages. Cottages housing older males also had pool tables.

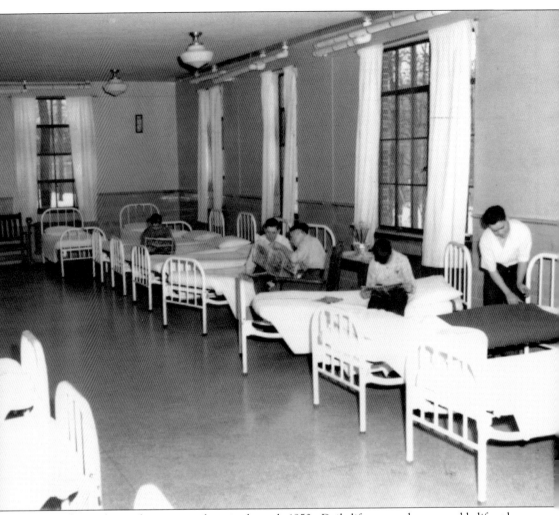

Residents relax in their cottage dorm in the early 1950s. Daily life was made to resemble life at home as much as possible, with chores and privileges as well as a little fun. Every child was encouraged to have his or her own toys. The cottages were built to house up to 100 residents each, with one attendant for every 25 residents. (Courtesy of the Leroy Mabery collection.)

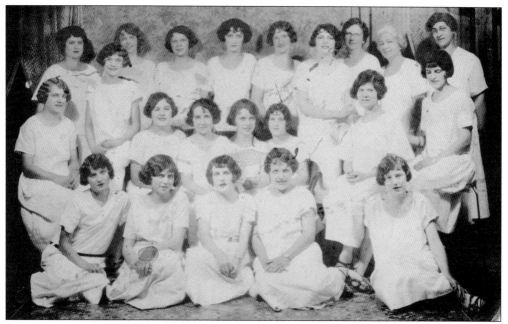

Estelle Rowden (back row, far right) was a nurse for the Lapeer State Home and is pictured with her charges in the 1920s. The girls are all wearing the same dresses, which they likely made themselves while learning sewing skills. Rowden was the sister of engineer Frank DesNoyer. (Courtesy of Jane Lewis.)

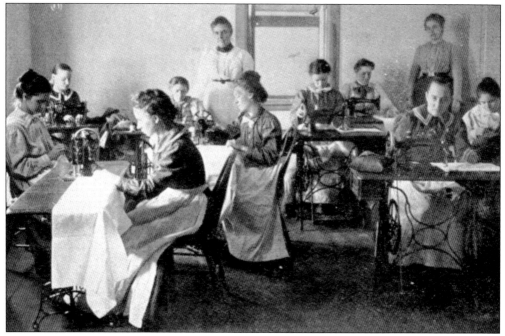

Residents are shown making dresses in this image from the home's 1900 biennial report. Fannie Bullock (background, center) was a seamstress who earned $12 per month. Mrs. E.W. Torrence, sewing-room superintendent (background, far right), earned $28 per month. Braided rugs were made with the scraps from the sewing room.

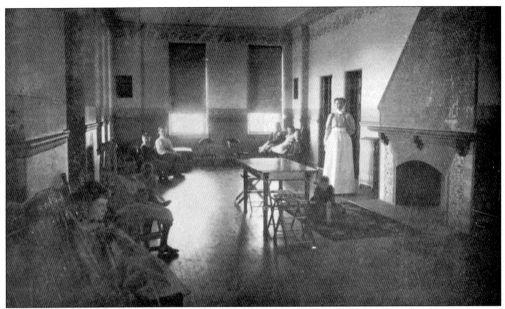

Young residents pictured here from the 1898 biennial report are in their cottage sitting room enjoying quiet time between their daily assignments with their attendant, W.L. Oldenburg. At this time, attendants earned $18 per month and were required to live on campus.

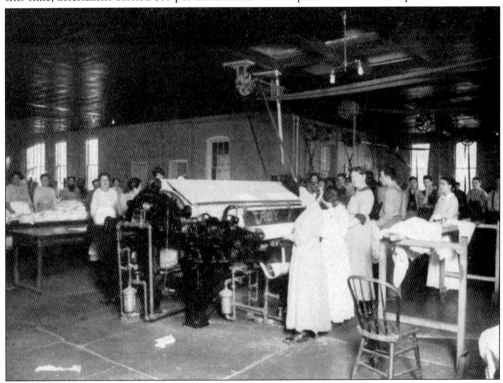

Staff and residents are seen from the 1914 biennial report working in the home's state-of-the-art laundry room. In 1944, it was reported that the laundry employed 90 residents and laundered 26 tons of laundry every week.

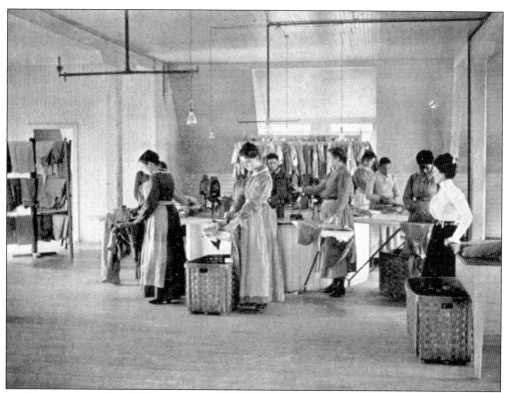

In this image from the 1900 biennial report, residents are hand ironing the home's laundry while overseen by their attendant. This laundry building was lost to fire in May 1902 and had to be completely rebuilt. Water was pumped from nearby Farmers Creek because the city water contained too many minerals that were damaging the laundry and pumping equipment.

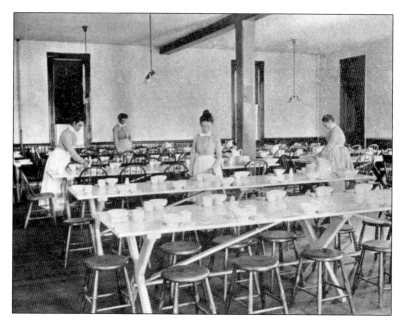

This photograph of the south dining hall in the 1900 biennial report shows the staff and resident workers preparing for a meal. At this time, all residents as well as staff were fed by the kitchen of the state home. Waitressing was considered a valuable skill for a female resident to have.

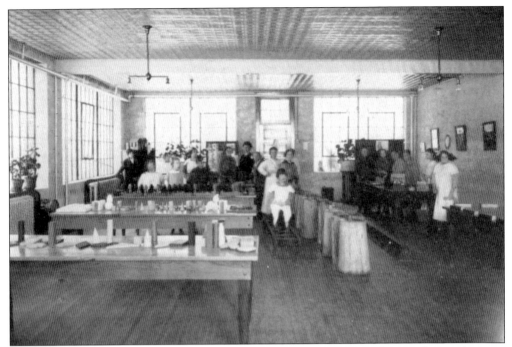

A group of residents is shown learning in the sense training room in the 1914 biennial report. The school believed in using four branches of education: academic, industrial, physical, and music. The staff kept the residents very busy during the day, going from one activity to the next.

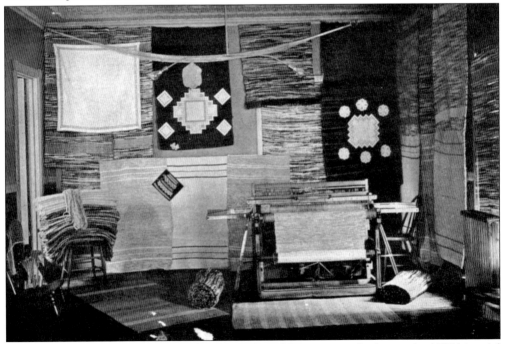

Textiles created by the residents of the Lapeer State Home are on display in the 1910 biennial report. At this time, additional teachers were added to teach industrial work, basketry, loom work, and vocal music, expanding the working-skills education for the students.

This manual training classroom shown in the 1912 biennial report shows off some of the skills learned by the residents, such as woodworking and textiles. Manual training was used to teach students manual dexterity and the concept of doing things instead of just thinking and learning about them.

This furniture seen in the 1910 biennial report was made by the residents, of very high quality, and used in the buildings of the Lapeer State Home. Residents were often moved from class to class to give them a broad spectrum of skills and allow them to find a skill they enjoyed.

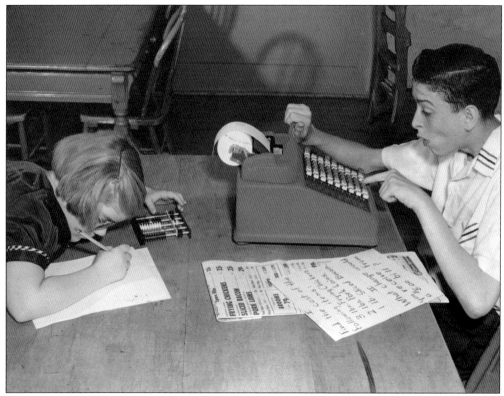

The Lapeer State Home was considered cutting-edge in education and was the first school in the state to implement a special-education program. This program was used as a model, and the home's teachers trained other special-education teachers across the state. (Courtesy of the Leroy Mabery collection.)

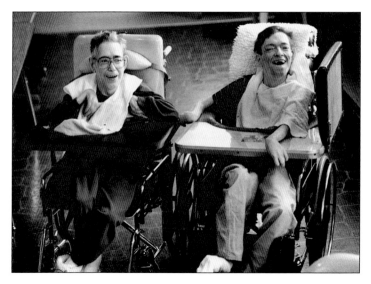

Before the Lapeer State Home closed in 1992, the remaining patients were considered completely dependent and required 24-hour care. Caring for these patients became more difficult, but it was very rewarding to the dedicated and patient staff. (Courtesy of Gloria Michelson.)

Four

THE FACILITIES

The Michigan Home for the Feeble Minded and Epileptic opened in Lapeer on August 1, 1895, with Cottages A and B and a dining hall. The original design of the home called for buildings to form a "quadrilateral" around a central dining hall, with residents separated by sex and class of illness or impairment. There were beds for 200 residents, which very quickly became inadequate. A waiting list started shortly after opening, and within a few years it was obvious to both the administration and the State of Michigan that an expansion was necessary.

In June 1897, Cottage C opened to house 100 more residents. Within the next few years, a laundry facility, a small hospital, a second dining hall, a kitchen, and a steam-heating boiler house were also added. The facility continued to grow, and two more cottages were built in 1901. Cottage D housed adult male epileptics and non-epileptics, and Cottage E housed "low grade" children of all ages and sexes and had its own dining room.

In 1913, the home changed its name to the Michigan Home and Training School. In 1937, it became the Lapeer State Home and Training School. The facility expanded constantly until its peak, when it had over 100 buildings covering over 1,000 acres. There was housing for over 4,000 residents, housing for staff, a fully functioning farm, and two hospitals with state-of-the-art equipment and some of the best doctors in the state.

In 1972, the home received its final name change to the Oakdale Regional Center for Developmental Disabilities. This marked the beginning of a series of changes in the function and purpose of the home. Serious budget and staff constraints were faced that eventually lead to its demise.

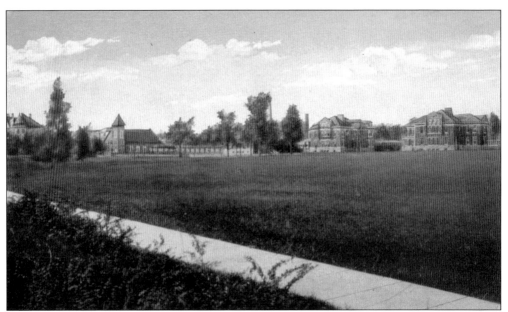

According to the Michigan Board of Control in 1898, buildings for the care of defectives should not be more than two stories, built for economy and durability, and use the best modern heating, lighting, ventilation, and fireproof conditions. Cottage C was built by residents to keep costs down. From 1896 to 1898, residents also constructed a laundry facility, a small hospital, a new dining hall, a kitchen, and a steam-heating and boiler house. (Courtesy of the Leroy Mabery collection.)

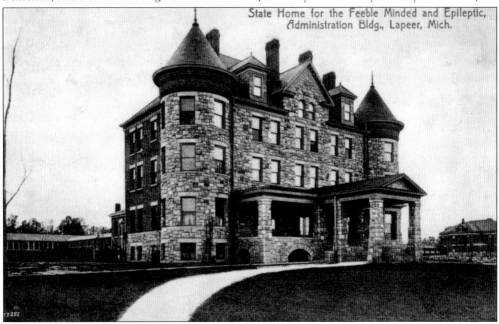

In 1900, a request was made to the State of Michigan for funds in the amount of $29,000 to construct an administration building. At the time, the medical superintendent and his family were living in the overcrowded hospital building. Plans for the building also included a dining room for officers and teachers, a dispensary, and offices for the physicians. (Courtesy of the Leroy Mabery collection.)

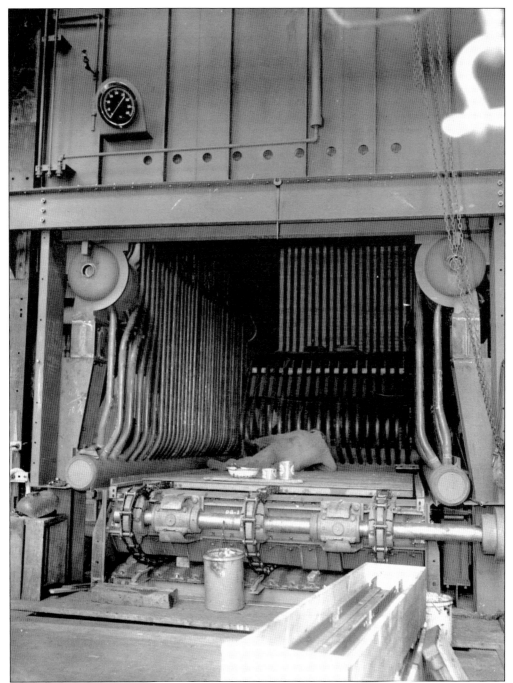

In 1901, the old boiler house was rebuilt into a storage house. In addition to storage, the second floor housed knitting and embroidery machines, a tailor, and a cobbler shop where shoes for residents were made. In 1923, the home had five boilers with 1,500-horsepower capacity. Ten thousand tons of coal was consumed yearly in the furnaces to provide light, heat, and power. (Courtesy of the Leroy Barnett Photograph Collection, Bentley Historical Library, University of Michigan.)

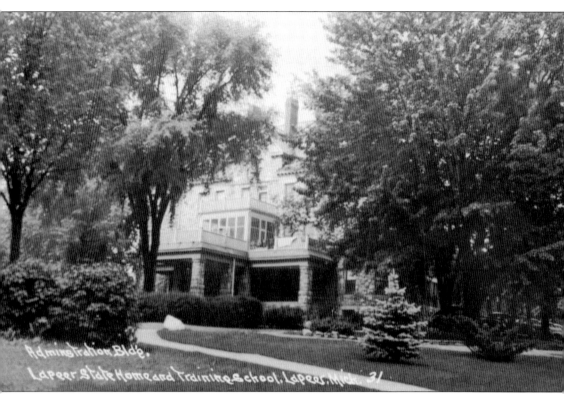

The administration building, later known as the Castle, was opened on March 1, 1902. This grand building was designed by architect Edwyn Albert Bowd and contained maple flooring, 99 windows, two parlors, 18 bedrooms, six bathrooms, and four flights of stairs. The cost of carpeting and furnishings for the building was asked for separately from construction costs in order to spread out the total expenses over four years. (Courtesy of the Leroy Mabery collection.)

Construction of the covered walkways spanned several years. They were built with a basement for the steam mains, water pipes, and wires. These walkways connected the buildings on the home's campus in order to keep residents safe, warm, and dry and to provide a place for some exercise during the harsh Michigan winters. (Courtesy of the Leroy Barnett Photograph Collection, Bentley Historical Library, University of Michigan.)

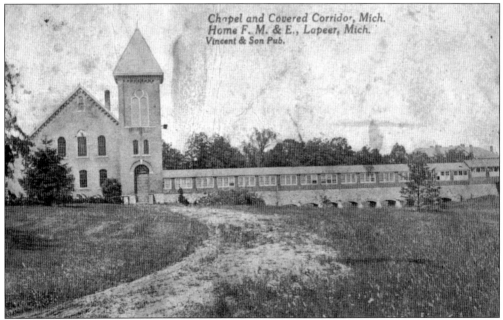

The covered walkways connecting the buildings on the campus were made almost entirely of windows and had hardwood floors. Being able to move residents from one building to another without having to maintain sidewalks, provide winter clothing, and worry about safety made life at the home much simpler. (Courtesy of the Leroy Mabery collection.)

55

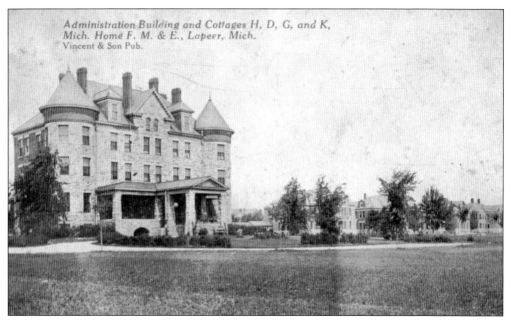

The administration offices and Cottages H, D, G, and K are pictured. Cottages F, G, and H were constructed in 1902. At that time, a building inventory included the administration building, Cottages A through F, a hospital, a library, a school, a dining room, a kitchen, a bakery, cold storage, engineering and carpentry shops, a laundry facility, and a sewing room. (Courtesy of the Leroy Mabery collection.)

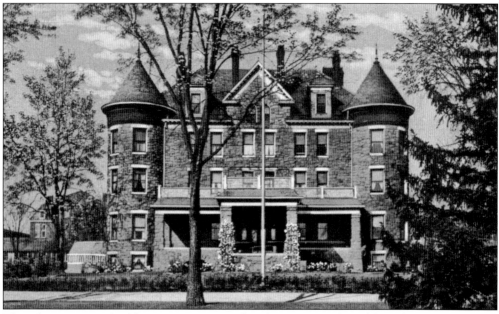

The administration building was constructed with stones purchased from local farmers who brought in 70 loads from their fields for $15 per load. The bricks were purchased from Lapeer Brick and Tile on Bentley Street and the Callis Brick Making Plant for $10 per meter of bricks. The amount requested for construction of the building was originally declined by the state; it was later approved when Dr. Polglase appealed. (Courtesy of the Leroy Mabery collection.)

The early buildings of the home were partly constructed using brick from the Callis Brick Making Plant, which was established in 1855 by William Callis in Lapeer's Mayfield Township. Using local materials was considered cost-effective as well as important to the state, which believed in supporting the local economy. (Courtesy of the Leroy Mabery collection.)

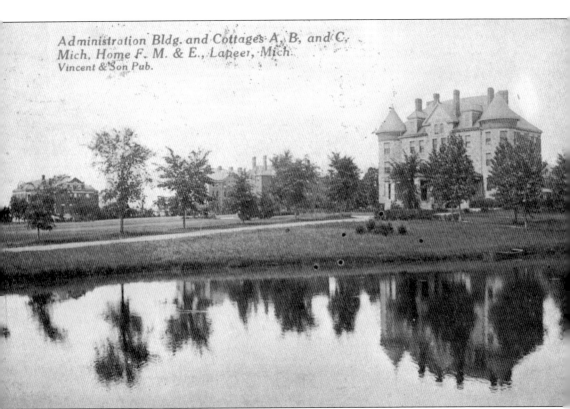

In the 1902 Report of the Board of Control of the Michigan Home for the Feeble Minded and Epileptic to the State of Michigan, Dr. Polglase requests $8,500 for furnishings for the administration building, suggesting it be "well and substantially equipped with such furniture and fixtures [that] are of good and lasting quality, rather than gaudy." (Courtesy of the Leroy Mabery collection.)

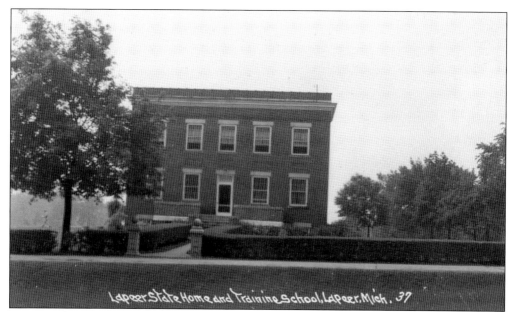

In 1902, there were eight cottages housing 75–100 residents each, a small hospital with 25 beds, a steam plant, a laundry, a storehouse, a small bakery, a cold-storage building, two dining rooms, several miles of fencing, and 25,000 square feet of cement walkway. A dam and retaining wall were also built, making a pond for ice supply from Farmers Creek. (Courtesy of the Leroy Mabery collection.)

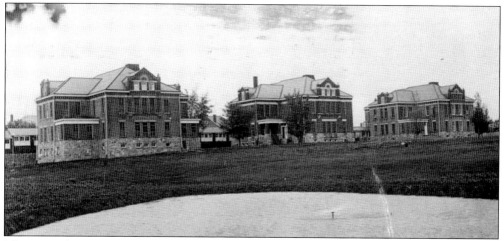

The original cottages of the Lapeer State Home were not barrier-free, and handicapped residents were required to climb stairs. The fire safety in the buildings was of great concern, as there was no way to get the physically challenged residents out of the building quickly and safely. (Courtesy of the Leroy Mabery collection.)

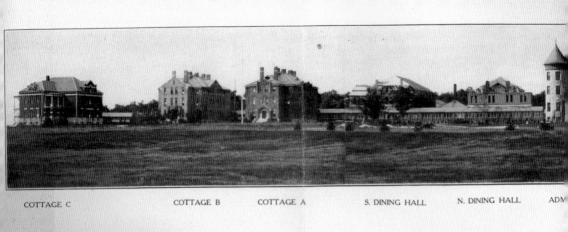

This panoramic photograph from the 1904 biennial report shows the expanding campus of the Lapeer State Home. The chapel was completed in September 1904 and seated 700 people. There

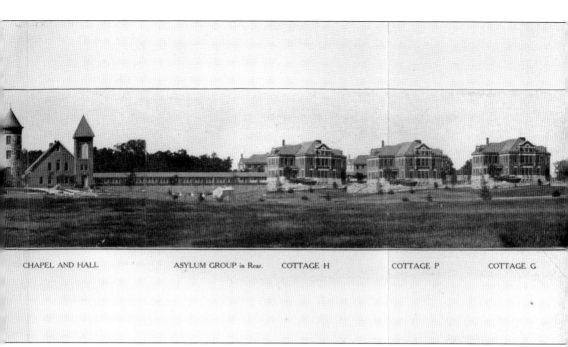

CHAPEL AND HALL ASYLUM GROUP in Rear. COTTAGE H COTTAGE P COTTAGE G

was also a sitting room for employees at the back of the chapel, with a gymnasium and bowling alley in the basement for the employee's recreation while off duty.

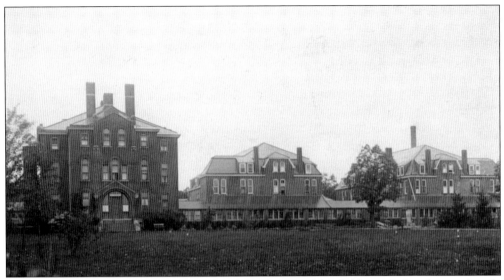

The original cottages were not designed well for the use of the feebleminded and were cheaply constructed. There were numerous safety issues, and after a 12-year-old boy fell from the second story of one of the cottages and broke his arm, all the buildings were fitted with window guards by June 1898. (Courtesy of the Leroy Mabery collection.)

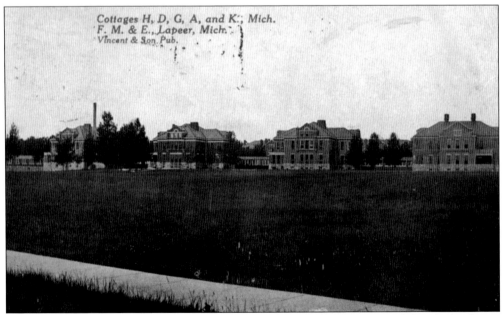

Cottages H, D, G, A, and K are shown. In 1908, Cottages H, D, and G were built beside the dining hall and contained male residents. Cottage D was constructed by the residents of the home in June 1898 and housed 100 male epileptic patients. (Courtesy of the Leroy Mabery collection.)

In 1908, the administration wanted to hire a landscape architect to make the grounds look as nice as some of the other asylums that had been seen. As it was suggested, in September 1909, the artificial pond next to the Castle was completed by the able-bodied male residents of the home. (Courtesy of the Leroy Mabery collection.)

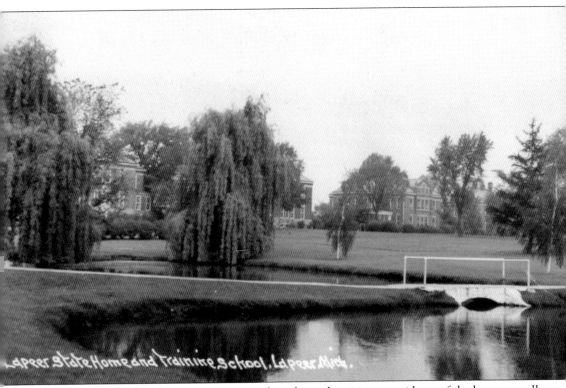

The grounds of the home were meant to be calm and inviting to residents of the home as well as to the community. It was important to the administration that the home never be considered an eyesore. The view in this photograph looks from the lake to Cottages 28, 21, 24, and 25. (Courtesy of the Leroy Mabery collection.)

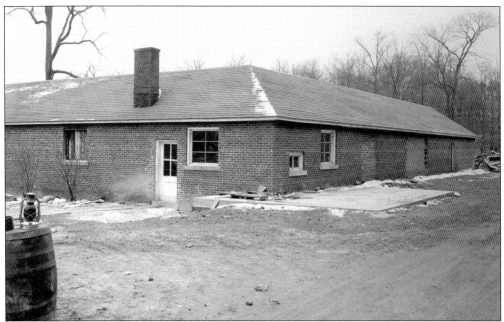

In 1909, a coal shed was built behind the boiler house to keep the coal dry during the spring and winter months. The lumber shed, pictured here, was also built and was used to house any wood being used for projects in the industrial building, such as furniture making. This building was demolished in 1957. (Courtesy of the Leroy Barnett Photograph Collection, Bentley Historical Library, University of Michigan.)

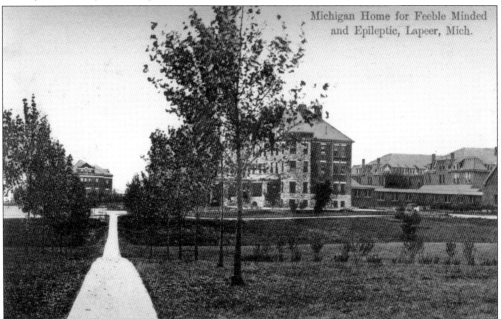

To further improvements to the grounds, in 1910, additional concrete walkways were put in around the campus of the Lapeer State Home. More than a mile of walkway was placed, and the project was to be extended to make a continuous concrete walkway from the main buildings all the way out to the farm. (Courtesy of the Leroy Mabery collection.)

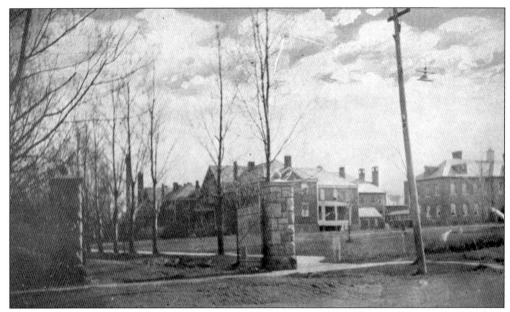

This photograph of the service ward entrance shows the iron fence that was put up in 1910 along the street in front of the grounds and the cut-stone posts that were built for the gate and roadways. The fence was not meant to hold residents in; it was added only for visual interest. (Courtesy of the Leroy Mabery collection.)

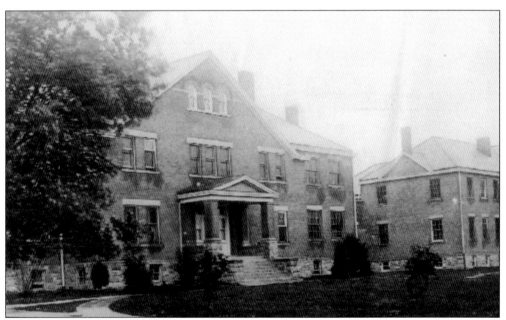

Cottages E and F were added to house female residents. They were constructed quickly, mostly by residents. After three years, the plaster and plumbing had to be replaced. In 1912, there were 191 people on the waiting list to be admitted by the probate court. Each cottage could house between 75 and 100 residents. There was one attendant for each 25 residents. (Courtesy of the Leroy Mabery collection.)

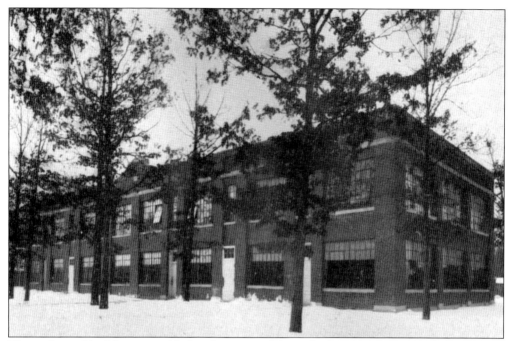

This industrial building was added and is pictured from the home's 1914 biennial report. This building cost $12,000 to build and contained eight 33-foot-by-50-foot rooms. The rooms included a carpenter shop, machine shop, and sewing and mending room, as well as rooms for sense training, calisthenics, manual training, rug weaving and a basket-weaving and caning room.

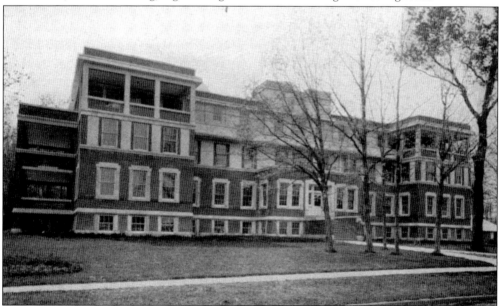

The hospital is shown in this photograph from the home's 1916 biennial report. The first floor was designed to house 40 male patients who could not care for themselves. The first floor also had a surgical room. The second floor housed 40 female patients who were considered "helpless" physically and mentally. The third floor provided a common area, including outdoor balconies. The kitchen and laboratory were housed in the basement.

The tuberculosis pavilion is pictured here from the home's 1916 biennial report. These patients were kept separate from the other residents to minimize the spread of the disease. At the time, it was believed that rest and fresh air was the best treatment. Patients had about a 50 percent chance of survival.

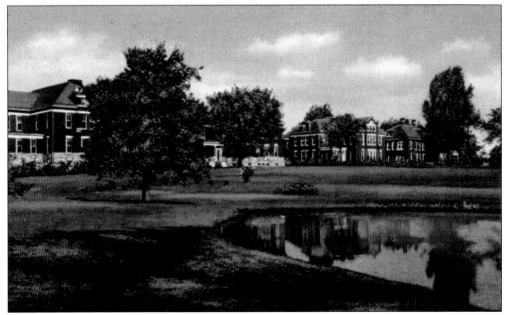

This photograph shows the ever-growing campus of the home. In 1919, the local Lapeer newspaper reported that the Lapeer State Home was the biggest of the five in Michigan; shortly before that, it was described as the largest institution for the mentally deficient in the world. (Courtesy of the Leroy Mabery collection.)

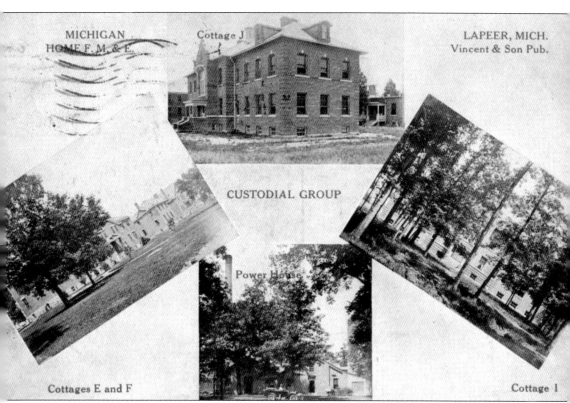

In 1922, the value of the home's campus was $1.25 million with 710 acres, 85 buildings (80 of which were for the 2,026 residents), and a cost of 60¢ per day, per resident. In 1923, the state approved funding for a new girls' hospital to be built. The older hospital would become the boys' hospital. (Courtesy of the Leroy Mabery collection.)

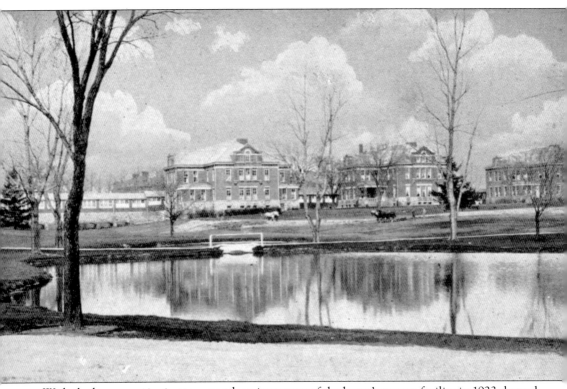

With the home continuing to expand, an inventory of the home's storage facility in 1923 showed on hand 7,937 pairs of footwear and 4,164 pairs of overalls, as well as thousands of yards of fabric. (Courtesy of the Leroy Mabery collection.)

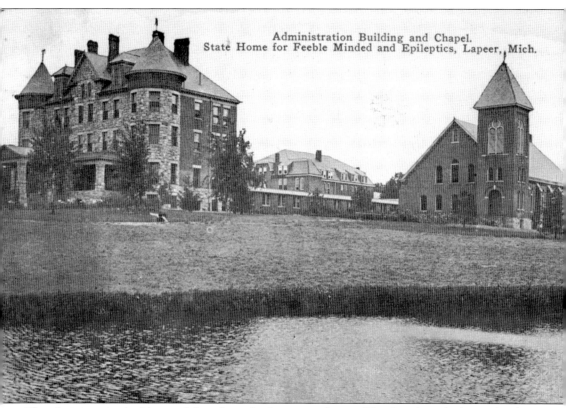

The administration building and chapel were both victims of arson. The chapel caught fire on April 22, 1939, and was burned beyond repair. Fifteen residents were trapped in the basement when the stairway was blocked by fire, but they escaped unharmed through windows. The administration building caught fire in 1973 after it had been condemned and vacated three weeks earlier. It was demolished shortly after the fire. (Courtesy of the Leroy Mabery collection.)

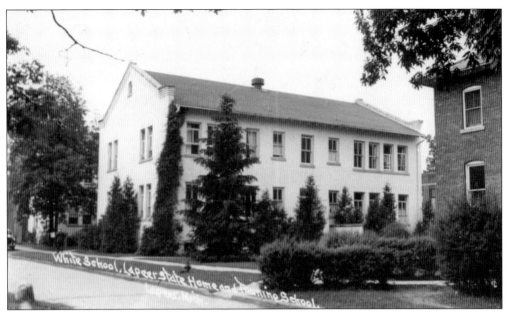

The White School, shown here, was the first school built on the campus. The administration believed in the benefits of not only traditional schoolwork, but also physical education including fiber crafts, calisthenics, vocal work, and instrumental music. In 1898, Dr. Polglase believed that physical, manual, mental, and moral training combined with a home life with amenities would bring about results that would give evidence to future usefulness. (Courtesy of LDL.)

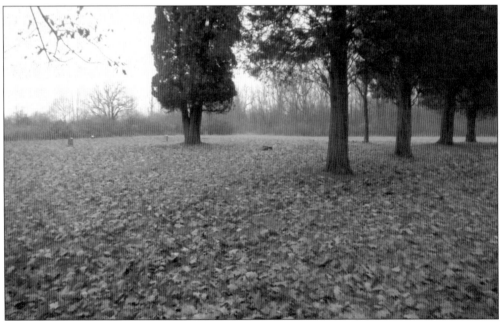

The local Lapeer newspaper reported in 1919 about a yearly Memorial Day ceremony that took place to honor the deceased buried in the home's cemetery. There was a parade back to the cemetery, and the residents and staff would picnic while the band played. Each grave would be given a red geranium and a prayer. (Courtesy of LDL.)

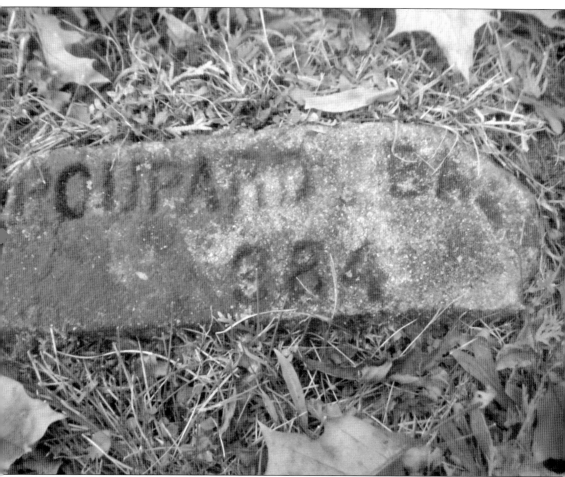

It was reported that between 1905 and 1946, some 416 residents were buried in the Lapeer State Home's cemetery. Most graves are marked with brick markers that were provided by the state, and many have sunken out of sight. With the implementation of social security, other funeral arrangements were made outside of the home's cemetery. (Courtesy of LDL.)

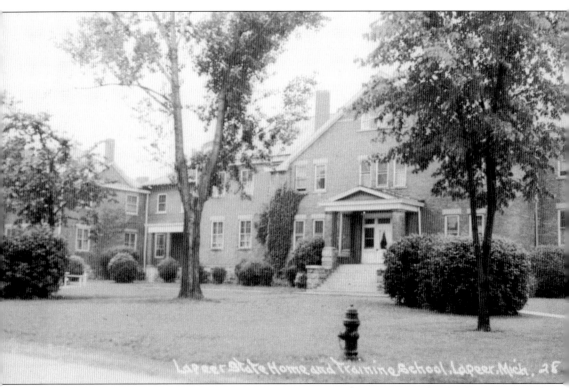

By 1951, the home was approved by legislation for a new $400,000 laundry facility that would be able to process the home's 40 tons of laundry per week with modern, laborsaving equipment. Individual cottages, such as Cottage F shown here, did not have their own laundry facilities. Large safety pins with the cottage number were attached to each bag of laundry to show where to return the items. (Courtesy of the Leroy Mabery collection.)

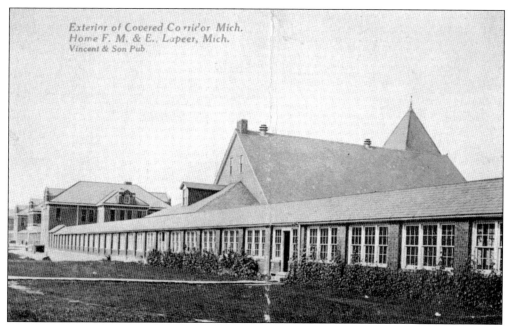

With the addition of buildings to the campus, the covered walkways also expanded. At one time, they were reported to be the longest in the world. They also greatly contributed to the comfort and safety of the residents and staff. (Courtesy of the Leroy Mabery collection.)

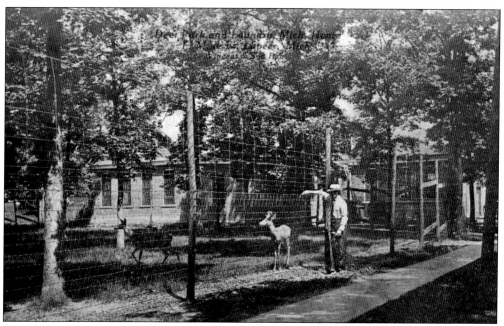

Providing activities for residents, such as this deer farm, was very important to the administration, especially since many residents would never live outside the home. In 1964, the Parents Association provided $2,000 in playground equipment and sought donations to add additional activities to the grounds. In 1967, a merry-go-round with 20 horses was installed as a result of donations and the home's Resident Benefit Fund. (Courtesy of the Leroy Mabery collection.)

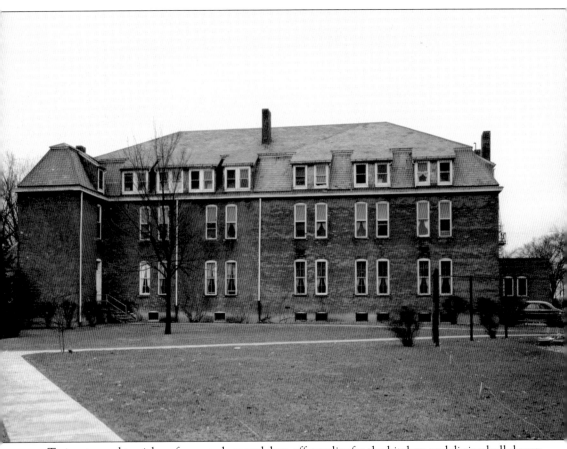

Trains stopped to pick up farm produce and drop off supplies for the kitchen and dining hall shown here. They received up to 60,000 pounds of flour, which lasted the home 200 days. By 1952, the bakery provided 1,500 double loaves of bread each day, 400 dozen donuts, 700 dozen cookies, 25 sheet pies, and 40 shortcakes per week for staff and residents. (Courtesy of the Leroy Barnett Photograph Collection, Bentley Historical Library, University of Michigan.)

This photograph shows staff outside the second dining hall. In the original dining hall built in 1898, employees were housed on the third floor, which contained 14 rooms. They were provided housing and meals as part of their salaries. (Courtesy of the Leroy Barnett Photograph Collection, Bentley Historical Library, University of Michigan.)

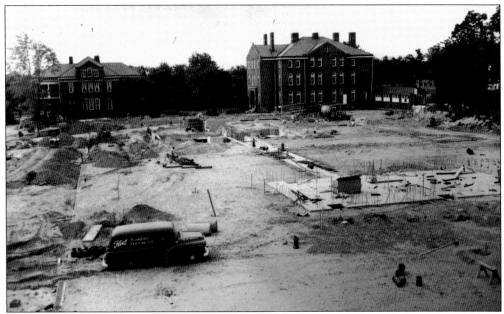

Dr. Rehn, the medical superintendent from 1947 to 1960, procured funding from the State of Michigan for a nursery, shown here in the early stages of construction after Rehn's death in 1961. Cottage A (Building 18) was demolished to make room for the new nursery. (Courtesy of the Leroy Barnett Photograph Collection, Bentley Historical Library, University of Michigan.)

In 1962, construction continued on the nursery (Building 45) to house 196 patients up to age 12 who required "infant care" and were thus unable to care for themselves. All nursery patients were in cribs. It took 72 employees, 24 hours, and 365 days per year to care for these patients. Able-bodied female patients also helped. In the back are Cottages C (left) and B. (Courtesy of the Leroy Barnett Photograph Collection, Bentley Historical Library, University of Michigan.)

Five

THE FARM

The Lapeer State Home Farm began only with a farmhouse, piggery, slaughterhouse, and dairy barn. Agriculture was the number-one employer in Lapeer County and was considered an important asset for the home as well. By 1900, the farm included 355 acres of fruit trees, gardens, and pastureland. Stables, an additional 200 acres, a coach barn, and a 12-bed farm cottage were added in 1902 when the farm had grown to house 45 Holstein cattle.

By 1920, the home farm was winning awards for its butterfat production, which was up to 71 pounds per cow, per month. The dairy farm was well respected, and the meat and dairy produced won awards across the country. In 1946, the home's bull won first prize in the Waterloo, Iowa, National Dairy Show.

At its peak, the home farm included 1,300 acres and the labor of 10 paid employees and 100 male patients. The work was considered therapeutic and gave the patients a sense of ownership and pride. However, the state legislature felt the work exploited the patients, and the farm was closed down in the fall of 1959. As a result, the home then had to purchase all of the meat, produce, and dairy that were once provided by the farm, adding additional expenses to an already shrinking budget. After the farm closed, the dairy barn was remodeled into a roller-skating rink, and the bull barn became a petting zoo.

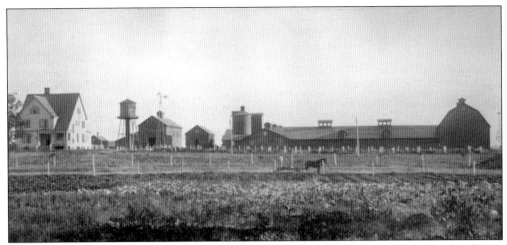

This photograph from a biennial report shows all of the farm buildings in 1912. The farmhouse on the left was constructed in 1908. The barns housed cattle, pigs, and chickens, providing all the meat and dairy for the home.

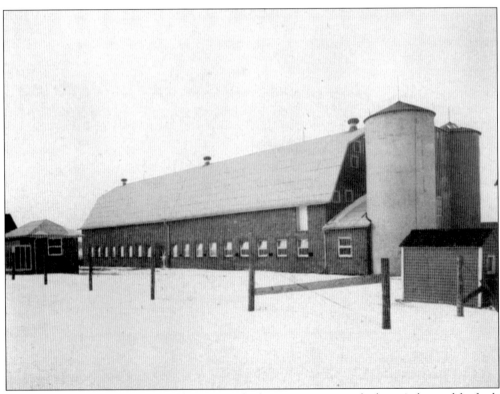

Originally, the dairy barn only held 13 cows, which was not meeting the home's demand for fresh milk. This new dairy barn and silos were built in 1914 when the home started pasteurizing its milk. By 1922, the home farm reported 120 Holstein cattle producing 34 ounces of milk per day, per child. This photograph is from the home's 1914 biennial report.

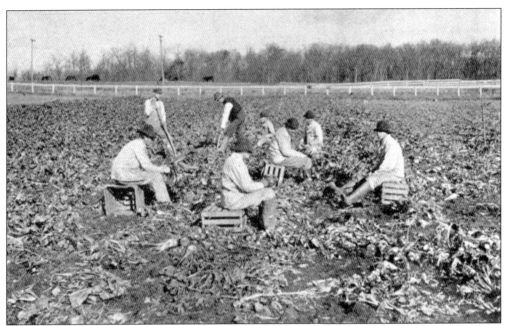

In an image from the biennial report from 1900, residents are shown working in the five-acre sugar beet field. The farm's garden also supplied potatoes, carrots, tomatoes, watermelon, muskmelon, lettuce, squash, cabbage, and strawberries. The farm provided all of the home's milk, eggs, chicken, and pork products. By 1923, the farm reported 710 acres, 450 of which were cultivated for crops. The rest included buildings, grounds, an orchard, and lowlands for livestock grazing.

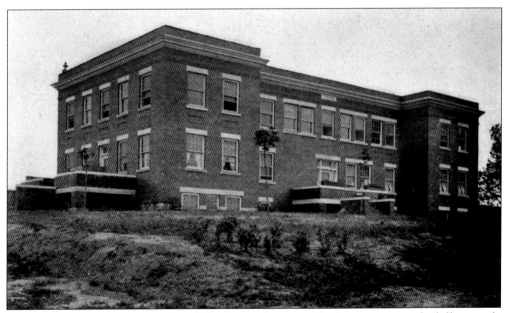

In 1918, the administration believed the farm colony was the best way to teach skills to male residents past school age. The farm was producing $39,800 worth of farm produce, and by 1935 that number rose to $55,000. This 1918 biennial report photograph shows the newly erected farm colony cottage that housed up to 100 male residents.

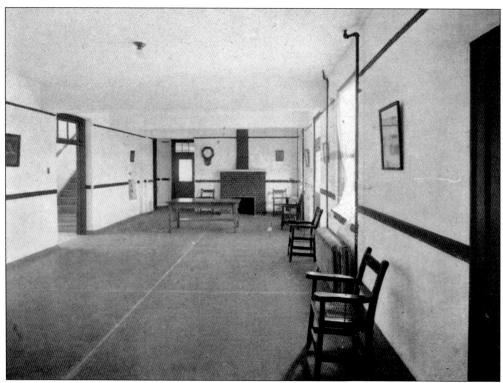

These images from the 1918 biennial report show the inside of a farm colony building. This dayroom above provided a place for the men to rest after a hard day's work. The colony cottage dormitory rooms below housed a minimum of 20 residents. Three identical colony cottages were located south of the main campus next to the railroad tracks: Buildings 10, 11, and 12. By this time, the farm had 53 head of cattle and was able to sell a surplus of 6,540 pounds of pork from pigs that were fed the home's dining hall scraps.

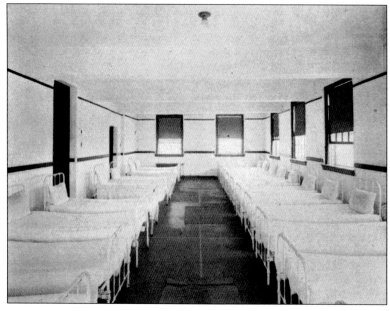

An annual Beef Banquet was held at the home dining room for farmers across the state. A meal was served and prepared by the home's kitchen staff. Music was provided by the home's glee club and band, and speakers discussed the changes in livestock laws. The banquet was followed by a beef auction that sold as many as 47 beef and dairy cattle. The home's surplus meats, milk products, eggs, and produce were sold to help keep the annual cost to house the residents down. (Both, courtesy of Don McCallum.)

Seventh Annual Lapeer
BEEF BANQUET

Lapeer State Home Dining Rooms
October 11, 1945
7 o'Clock

Sponsored by
**The
Lapeer Chamber of Commerce**
Earl Smith, President
Dr. H. B. Zemmer, Beef Sale Chairman

Banquet Program
Dr. H. B. Zemmer, chairman

Invocation - The Rev. J. Paul Pumphrey
Introduction of Toastmaster Dr. H. B. Zemmer
Toastmaster - - - M. A. Gorman
 (managing editor Flint Journal)
Greetings from the Lapeer State Home
 Dr. R. E. Cooper, Superintendent
Lapeer State Home Saxophone Quartet
 Directed by Herbert Murr
Introduction of Guests - C. L. Bolander
 (Deputy Commissioner of Agriculture)
Music - Ramblers Quartet of Lansing
Effect of Michigan's New Livestock Laws and
 Regulations - - - Charles Figy
 (State Commissioner of Agriculture)
Lapeer State Home Girls' Glee Club
 Directed by Mrs. Kruth
Where Are We Going from Here?
 Prof. George A. Brown
 (Animal Husbandry Department MSC)
Bell Solo - - - Bobby Thompson
 Lapeer State Home Patient
Music - - - - Ramblers Quartet
Address - - - - Kim Sigler
The International Livestock Market, and introduction of Beef Sale Consignors
 George Branaman
 (Associate professor of Animal Husbandry MSC)
Music - - - Ramblers Quartet
Tomorrow's Sale - - S. A. Mahaffy

Farming was considered a valuable skill for the male residents to have, and they, along with the farm employees, worked hard to care for the gardens and livestock. The home had as many as 20 teams of Belgian horses that pulled plows until 1927 when the first tractor was purchased. (Courtesy of the Leroy Mabery collection.)

Six

The Community

Since its beginning, the home has played a large part in the Lapeer County community. Many Lapeer-area citizens still remember when the home blew its whistle at 7:00 a.m., 12:00 p.m., and 6:00 p.m. daily. The Lapeer paper reported that it was "a great convenience for all." Families were often employed together, and most people in Lapeer had family members or knew someone who worked at the home.

At first, the home was a place that provided jobs and a state-of-the-art facility to be proud of. As the years continued and the facility grew, its size actually outpaced that of the city of Lapeer in 1945. It was the largest employer in Lapeer County for many years. It affected most every family in the city one way or another. Marriage announcements between staff employees appeared frequently in the papers, and want ads for staff advertised for married couples to work at the home. In earlier years, it was not uncommon for brothers, sisters, and other family members to be institutionalized together at the home. Families would also move into the area to be close to their children.

In the beginning, the superintendents made a special effort to invite the community inside of its walls, and events at the home were often covered in the society columns of local newspapers. The newspapers also reported on residents escaping from the home, which happened periodically since it was not a prison. Community members would often return residents to the home. Then, beginning in 1923, some residents were paroled to work in the community, and in the 1970s they were allowed to go into town for entertainment and shopping.

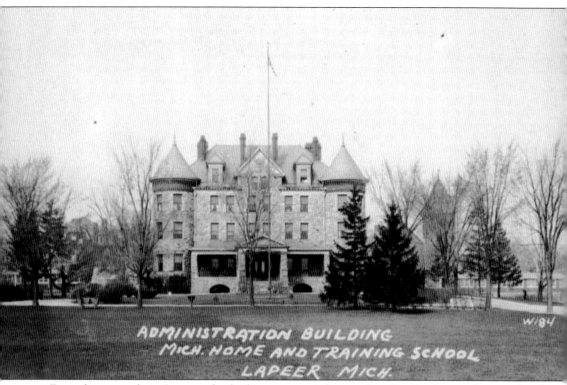

Even those people in Lapeer who had never seen it knew what the Castle was. It was a local landmark on the beautifully landscaped grounds of the home. When area citizens had out-of-the-area company, they often took them on a tour of the home. Community groups had outings on the grounds or would also tour the facilities. An early front view of the Castle is shown here. (Courtesy of the Leroy Mabery collection.)

In the beginning, visiting days were every Wednesday, and the home made extra effort to celebrate the holidays, sometimes with fireworks and picnics on the pastoral grounds. Residents helped maintain the grounds. (Courtesy of the Leroy Mabery collection.)

The Lapeer community was always invited to participate in special assemblies. The staff often organized dances that were held in the assembly hall, shown in this photograph from the 1898 biennial report.

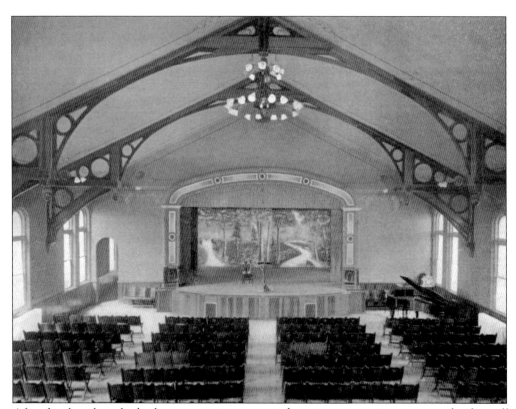

After the chapel was built, the community was invited to view presentations put together by staff and residents. Community members would also provide entertainment for the residents through musical and skit presentations. Early superintendent reports include notes like "thanks to Mrs. Carey for her presentation of 'Freezing a Mother-in-law,' Miss Florence Vincent for her music, the Lapeer Band for an afternoon concert, the Hon. C.W. Smith for frequent vocal renditions" and "to others of Lapeer who have contributed entertainment and gifts to our children." This photograph from the 1912 biennial report shows the interior of the chapel. (Courtesy of the Leroy Mabery collection.)

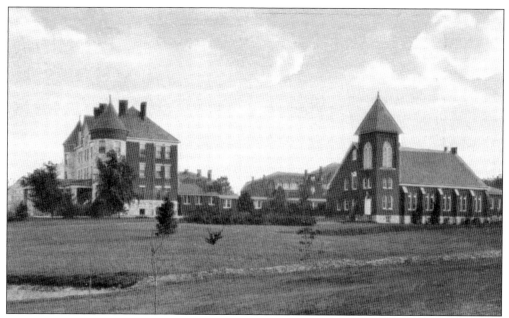

The exterior of the chapel and the castle are depicted in this postcard published before 1909—notice the absence of the pond that was created in 1909. (Courtesy of the Leroy Mabery collection.)

This scene pictured in the 1912 biennial report shows *The Waif's Christmas* performed by residents and attendants in December 1907. The *Flint Daily Journal* reported, "Quite a number of Lapeer guests were present to witness the performance. The children all did well and the play was pronounced one of the most successful ever given at that institution."

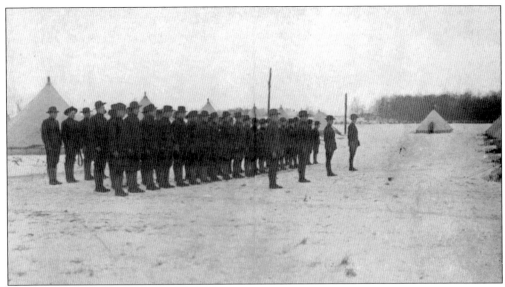

The smallpox quarantine of 1910 had the whole community of Lapeer up in arms—literally. Resident Emma Bophine was the first to contract smallpox and die. Attendant Bertha Mosher, who cared for her, would die shortly after. The home was placed under quarantine on November 8. On November 12, Company A, the Third Regiment of the Michigan National Guard camped outside the front gate and maintained quarantine until December 23, 1910, as shown here. (Courtesy of the Leroy Mabery collection.)

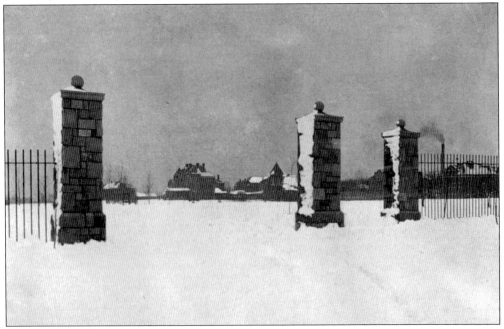

Lapeer-area physicians immediately vaccinated everyone at the home, but some had already contracted the disease. Those ill were quarantined in the schoolhouse and the hospital. Among the 33 cases, three employees and 14 residents died. After 1910, all residents were vaccinated for smallpox on arrival at the home. This photograph of the front gate of the home in the winter of 1910 is from a biennial report.

The home's marching band often gave concerts in the chapel. (Courtesy of LDL.)

Throughout the home's history, doctors believed that music was beneficial to the residents, and all the residents in school took music classes. Many of them enjoyed playing in the band. The Home Band gave concerts and was often invited to play at events and to march in parades. (Courtesy of the Leroy Mabery collection.)

The home had a parent committee that was established in 1949, which remained active until the facility closed its doors. Parents volunteered at the home and raised, from 1949 to 1968, almost $88,000. They helped develop the recreation area south of the railroad tracks by putting in restrooms and a picnic area and supplying a pontoon boat, a "train," a Ferris wheel, and a carousel. Pictured is the pond near the Castle. (Courtesy of the Leroy Mabery collection.)

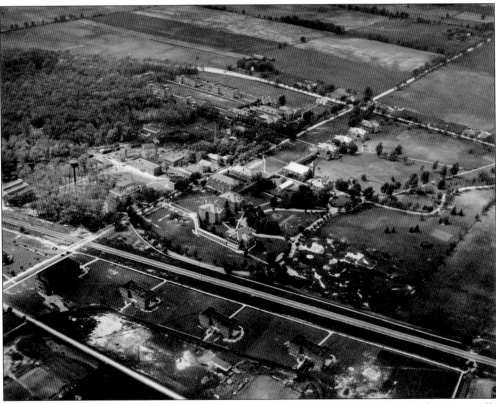

This aerial photograph from 1930 shows how big the main campus was. This is before it actually reached its largest size. The chapel, the Castle, and the North and South Dining Halls (the C-shaped building) are the large buildings in the center. To the north of the chapel on the right are the custodial cottages. To the north and on the left are the girls' cottages and the girls' hospital. South of the girl's cottages are the power plant, the industrial building, bakery, boys' hospital, water tower, and other utility buildings. South of the railroad tracks are the boy's cottages and the auditorium (on the left). Not shown are the farm buildings and the recreation area. This was taken before the buildings that are still standing were constructed. (Courtesy of the Leroy Mabery collection.)

Seven
CONTROVERSY

Like any large, state-run institution, the state home had its share of controversy and serious problems. The home was sued for false imprisonment, the pregnancy of a resident in the infirmary, and more infamously for the involuntary sterilization of residents in its early years. The exact number of sterilizations performed at the state home is not known, but one eugenics researcher claims that the number was 2,336; there were 3,786 documented cases of sterilization statewide. Others problems included abuse of residents by staff, accidental deaths of residents, crimes committed by escaped residents or residents on parole, and more. The home's last years would be plagued by union problems, management and employee disputes, and investigations of abuse.

The home was not an easy place to work, and attacks on staff did happen. In 1911, William Perkins, an attendant of Cottage G, was shaving residents when resident Grover Henderson grabbed the razor from Perkins and slashed Perkins's throat; Perkins recovered. Allegations of the abuse of residents made the paper far more often, and while investigations followed, not many ended up in court. The first case reported in the papers of resident abuse occurred in August 1905. Dr. Polglase had contacted the Koster family, asking them to take their children Albert and Frances home. The children each weighed 200 pounds, and Dr. Polglase believed that the home was not the best place for them. Just before their release, Albert died. He had a cut on his forehead and sores and bruises on his body. Albert's body was exhumed for examination, but no charges were pressed. One of the last reported cases happened in 1977 when three staff members were fired for patient abuse. The abuse included slapping residents and making a resident stand in a corner on his knees for four hours with his nose against the corner or putting his head in a toilet and flushing it. One resident had been hit by an attendant with his own shoe.

Since the home was not a mental asylum or a prison, it was fairly easy for residents to run away. Two residents in 1902 were the first reported "eloped" residents. The home at the time had a population of 443. Later, the number of residents running away from the home would rise. By 1916, the number of elopements was still rather modest at seven, from a home population of over 1,200. In the 1918 biennial report, the home resident population was listed as 1,543. Of those, 34 male and three female residents ran away and were not caught. Often, runaways would be returned to the home either voluntarily or by community members or the sheriff's department. The more outrageous exploits would make the local papers with headlines like these from the *Flint Daily Journal*: "Strange Visitor!" or "Has Strange Desires."

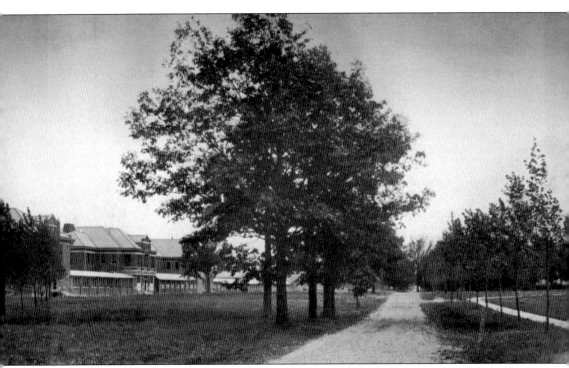

The first serious crime committed by a resident occurred in July 1924. Home employee Blanche Burke was found strangled along Demille Road. Authorities questioned several area itinerants. Lewis Johnson, who worked with Burke in the laundry facility, was finally identified by a resident who saw him leaving the home and by a staff member who saw him walking along Demille Road, shown here in a photograph from the 1912 biennial report.

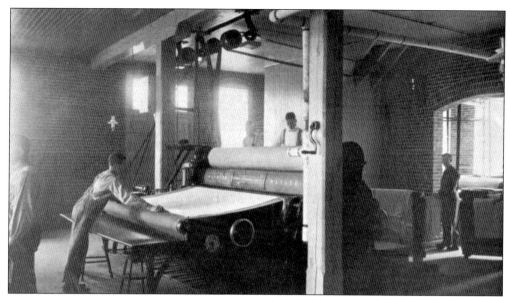

Another resident stated that Johnson had said he was going to kill Burke because she had reported Johnson for talking to girls. Johnson confessed when he was questioned by Sheriff Conley. Johnson, aged 20 and institutionalized since he was two or three, lived in Colony Cottage No. 3. He was sentenced to life in the Ionia Asylum for the Criminally Insane. This photograph from a biennial report shows residents working in the laundry and mangle (wringer) room in 1898.

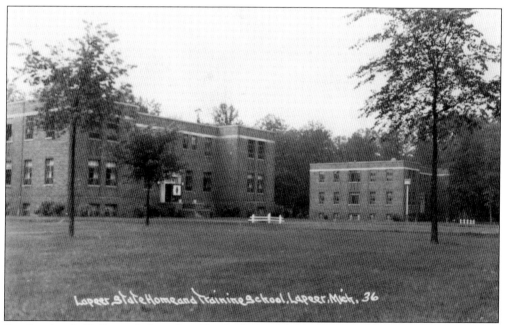

On October 3, 1949, paroled resident Elizabeth Fox, while working for the Merz family, stabbed the lady of the house in her bed. Normally shy and well behaved, Fox had become upset by the way she was treated in the household. Her full confession appears in the *County Press*. Mrs. Merz survived the stabbing but lost an eye. Fox was sentenced to 5–30 years at Jackson State Prison. This photograph is of female housing. (Courtesy of the Leroy Mabery collection.)

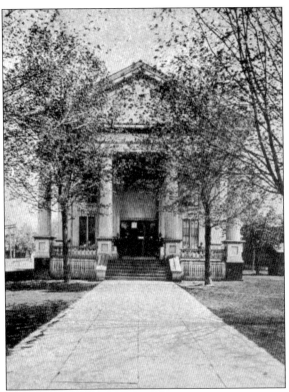

Most incidents caused by runaway residents were small and caused no harm, like 14-year-old resident Leonard Yates, who lived under the courthouse stairs, shown in 1904, for a week until he was returned to the home. Yates was often in the papers for everything from riding the railcars to Flint to robbing a jailhouse. Some crimes committed by runaway residents were more serious, like stealing cars and setting fire to buildings. (Courtesy of LDL.)

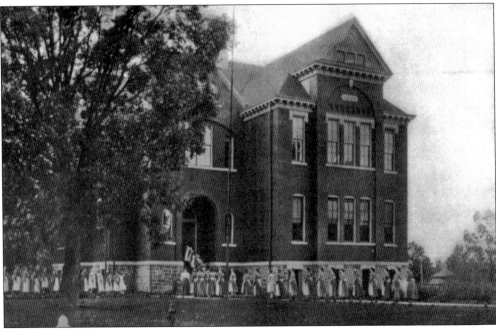

The first documented case of false imprisonment was that of Bessie Lewis. When she was 13, her mother became ill and was admitted to a sanatorium in northern Michigan, and Bessie was enrolled in the Adrian Industrial School for Girls, shown here in an image from the school's 1917–1918 biennial report.

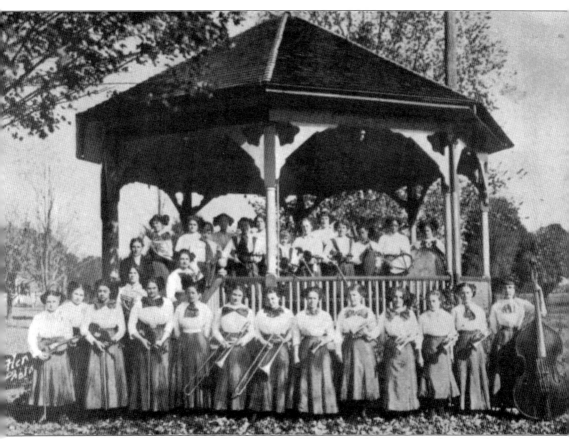

The lively Lewis had no interest in school but loved her music classes. Around 1906, after she spent two years in school and amassed a string of disobedient behavior, the school exaggerated Lewis's behaviors in her records and transferred her to the Lapeer State Home. Lewis's learning was already beyond what the home could provide, so she participated in its music classes, watched younger residents, worked in the laundry room, and had friends among the brighter residents. This photograph of the Adrian Industrial School for Girls band, in which Lewis played the cornet, is shown from the school's 1917–1918 biennial report.

Lewis, shown at left, was released to her mother in August 1913 at age 21. The home was cleared of any blame. The Michigan Board of Control initiated the passage of legislation to keep others from being wrongfully committed. After Lewis's release, every resident at the home was screened and sent before a judge. After her repatriation, Lewis found employment at a department store and began night school. Lewis would have lived in a cottage like this girls' cottage seen below, located near current-day Rolland Warner Middle School and seen in a photograph from the 1916 biennial report. (At left, courtesy of the Grand Rapids Public Museum.)

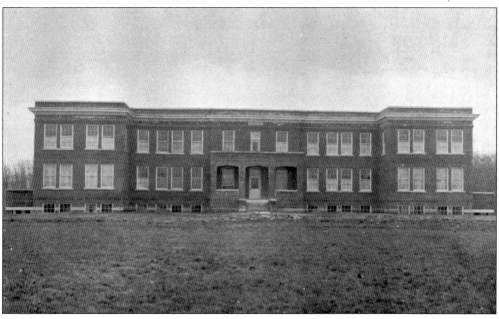

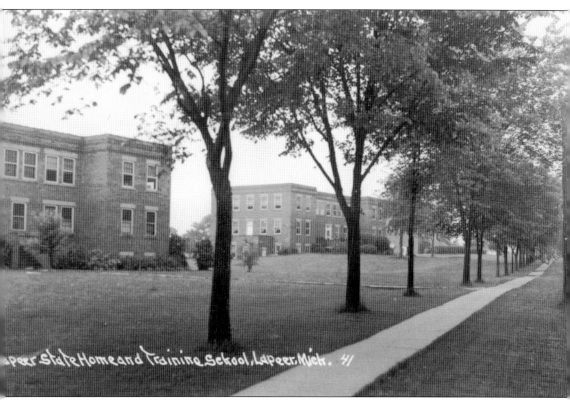

One case of false imprisonment went to the Michigan Supreme Court and was denied. Jack Smith was born in an institution and sent to the home from 1926 to 1964 with no court order. He remained in foster care until his death in 1984. Smith's estate contended that his rights had been violated and that being institutionalized resulted in his poor mental condition. Shown here is resident housing. (Courtesy of the Leroy Mabery collection.)

The first landmark sterilization case in Michigan occurred in 1915, when Dr. Haynes wanted to sterilize resident Nora Reynolds because she often ran away from the home and had twice returned pregnant. Her guardian said no, so Haynes sued, but his request was denied by Lapeer judge William Brown Williams in the Lapeer County Courthouse. In 1918, the Michigan Supreme Court agreed with Williams. (Courtesy of LDL.)

Then, in 1925, the parents of resident Willie Smith requested his sterilization. Smith's legal guardian objected. The Supreme Court of Michigan allowed his sterilization and said about the case that "the purpose of the act . . . is 'to authorize the sterilization of mentally defective persons'" and proceeded to state under what circumstances sterilization should be allowed. This gave Michigan institutions some leeway for sterilizing residents. A plaque commemorating the Nora Reynolds case hangs on the courthouse steps. (Courtesy of LDL.)

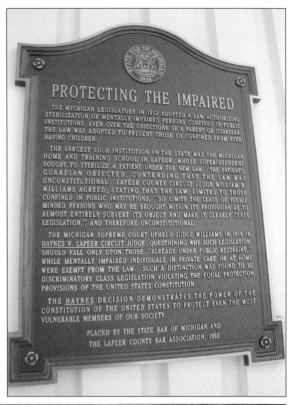

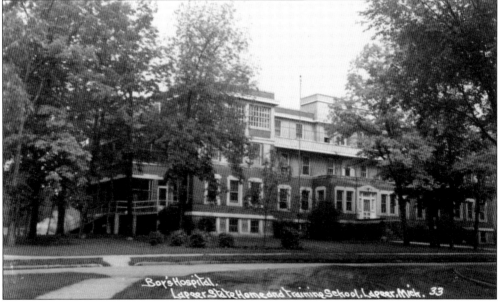

The most publicized sterilization case was that of Fred Aslin. Home records state that he and all his brothers and sisters (except for a sister who ran away) had been sterilized because they were feebleminded. Aslin believes it was because they were poor and Native American. He sued the State of Michigan in 2000 but lost his case because the statute of limitations had expired. Shown is the Boys' Hospital. (Courtesy of the Leroy Mabery collection.)

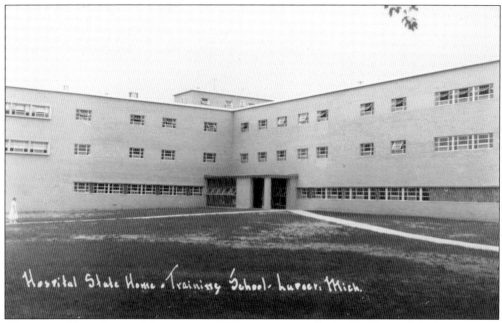

The most publicized case of abuse was in 1977 when profoundly disabled Linda Schafer was raped and became pregnant while she was in the infirmary. Her family sued the state, and the case was settled in 1984 for $282,000. It was never determined if the father of her child was a resident or a staff member. (Courtesy of the Leroy Mabery collection.)

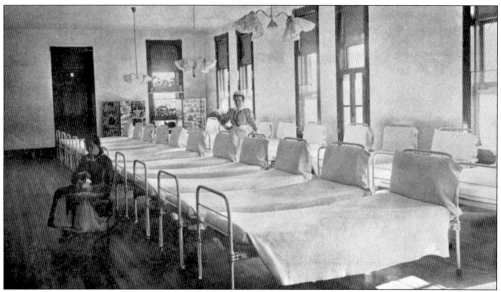

The home also struggled with overcrowding and understaffing. In 1945, the home had 4,950 residents and only 590 staff. From 1895 to the 1970s, each dorm room housed 25 residents—with no privacy and no place for personal items. In the 1970s, remodeled cottage dorm rooms had four beds and closets. Attendant Minnie Kinietz (or Kenetz) and an unidentified resident are shown in a Cottage A dorm room in this image from the 1900 biennial report.

Eight
DECLINE AND CLOSURE

In the beginning, the home was a model institution for others of its kind to follow. It began one of the first special-education training programs for nurses and teachers and was a leader in the care of the mentally disabled. By 1938, the home would encompass more than 100 buildings and cover 898 acres with an additional 1,335 acres rented. According to the *County Press*, in 1945, the home would hold more people than the city of Lapeer and would reach its peak population of 4,950. The *Flint Journal* placed its peak population at 4,467 in 1956. By 1976, only 22 buildings would still be in use and would house only 1,200 residents, though the home would remain Lapeer County's largest employer with 1,325 staff.

In 1957, funding for the last buildings to go up was appropriated: the hospital (near current-day Chatfield), the nursery (Mott Community College), and Woodside School (Rolland–Warner Middle School). By the time that Dr. David Ethridge became the last superintendent in May 1976, conditions at the home had deteriorated and ideas about care of the mentally disabled were changing; the home no longer met minimum standards of health care for its residents. Ethridge's tenure would be marked by almost constant change and turmoil, and the home was plagued by staff strikes, union lawsuits, and a resident-abuse lawsuit. By the 1980s, resident population was down to 759, with 1,027 staff to care for them and the grounds of the home. By 1988, there would be 680 staff and 315 residents. The home would finally close in September 1991.

The property of the Lapeer State Home was sold to the City of Lapeer in 1992 by the State of Michigan for $1 with the stipulation that the property could only be used for local government and public education. This property included 24 buildings and hundreds of acres of land. The cost to demolish the unsalvageable buildings was $550,000. The only three remaining buildings are the nursery (Mott Community College), an administration building (Chatfield Charter School), and a school building (Rolland-Warner Middle School).

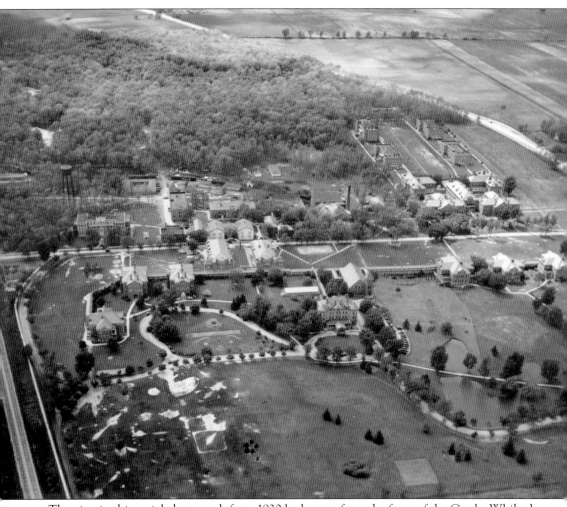

The view in this aerial photograph from 1930 looks west from the front of the Castle. While the home encompassed more than 2,000 acres in 1938, it continued to grow until the 1960s. (Courtesy of the Leroy Mabery collection.)

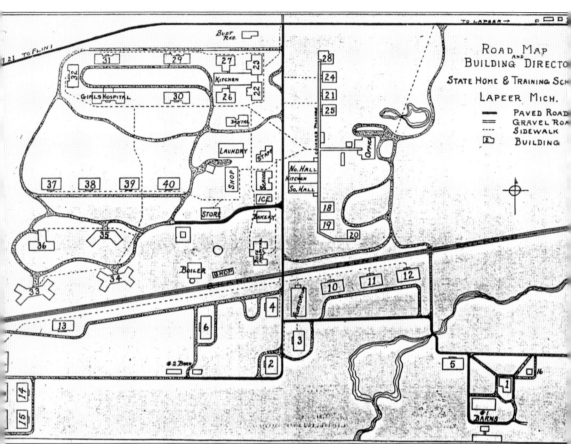

This map dates between 1939 and the early 1960s. The chapel burned down early in 1939 and is noticeably absent, as are the new buildings constructed in the early 1960s: the nursery (Mott Community College), hospital, the hospital administration building (Chatfield Charter School), and school (Rolland-Warner Middle School). Buildings 18 and 19 (Cottages A and B) are the only remaining structures from 1895. The Castle is identified as the "Office." (Courtesy of LDL.)

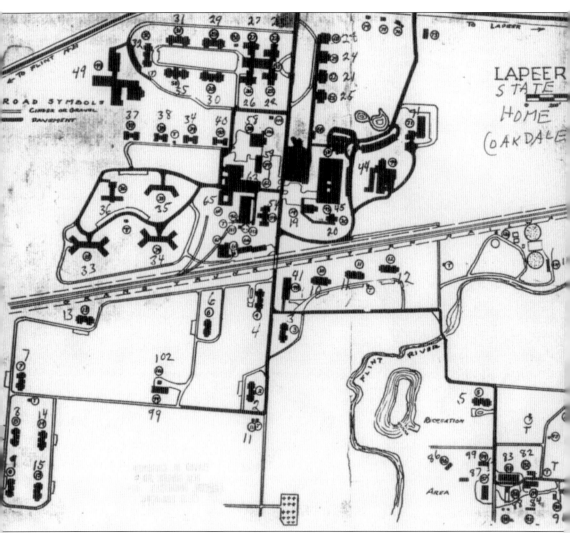

This map of the home is from after 1960 when Woodside School (Rolland-Warner Middle School, Building 49), the nursery (Mott Community College, Building 45), and the hospital (Building 44) were constructed and before several buildings were demolished in 1973. This is the first appearance of the cemetery on known existing maps, though it was put into service much earlier. This map would have been made at or near the home's peak years. Building 18, also called Cottage A and the first building erected at the home, had been torn down to make way for construction of Building 45. (Courtesy of Don McCallum.)

This photograph of the inside of Cottage F in 1948 shows the poor condition of some of the older buildings that could not be restored. The first round of large-scale building demolition would begin in October 1973. (Courtesy of the Leroy Barnett Photograph Collection, Bentley Historical Library, University of Michigan.)

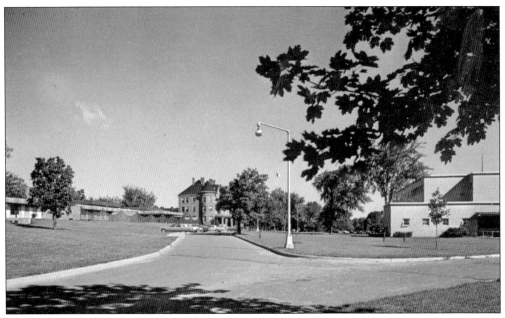

This postcard view shows the Castle from the south side looking north. On the left is the nursery, and on the right is the newest hospital. The photograph probably dates from the early 1960s, when the nursery and the hospital were first built. The hospital seen here closed in the early 1980s. Building 45 would be remodeled into residential units and then finally Mott Community College in 1993. (Courtesy of the Leroy Mabery collection.)

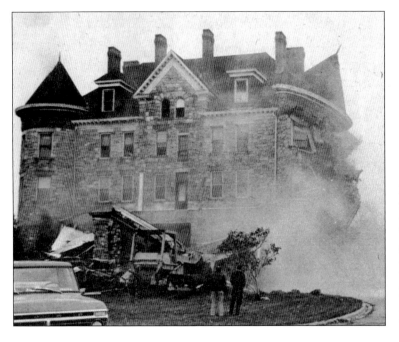

Nine buildings were raised, including the Castle, in 1973. The buildings demolished included the earliest Cottages B (19), C (20), and E and F (22 and 23). (Courtesy of the *County Press*.)

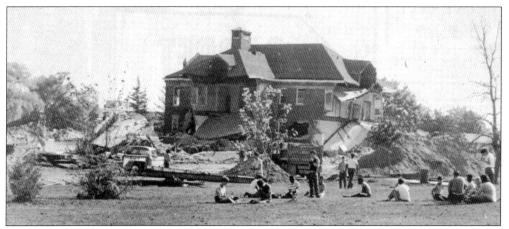
Large groups of Lapeer-area citizens watched the demolitions in this photograph that appeared in the *County Press*. (Courtesy of the *County Press*.)

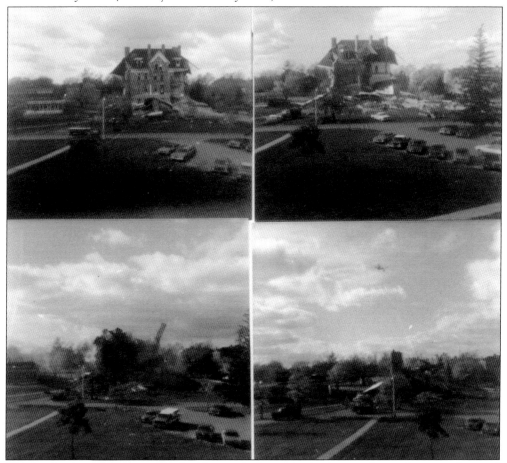
The Castle, the most recognizable building at the home, had to be torn down after it was damaged by arsonists on January 6, 1973. Home administration had already moved to the building that is now Chatfield Charter School, so the building was being used for storage at the time of the fire. (Courtesy of Don McCallum.)

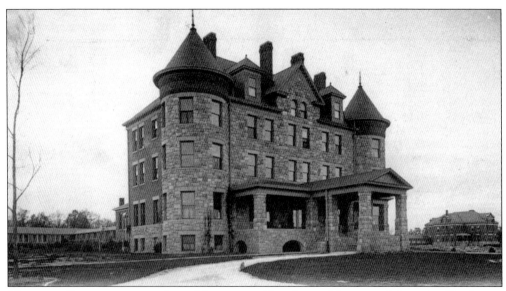

The upper floors were not safe, and it was considered too old to remodel, so the Castle was scheduled for demolition. The community had started a drive to save it and use it as a museum about the home at the time it was burned. It was demolished in November 1973. (Courtesy of the Leroy Mabery collection.)

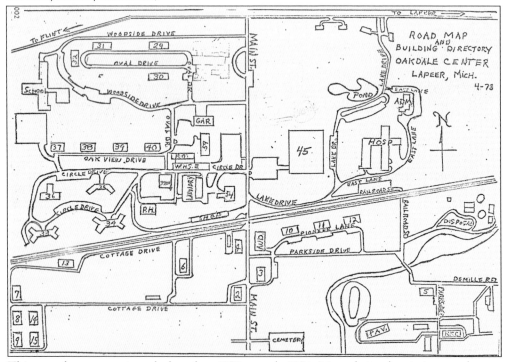

This map dates approximately from late 1973 to early 1974. Most obviously missing are the rest of the earliest buildings (numbers 19–26), the women's hospital (Building 55) and the Castle, most of which had been constructed before 1910. The White School is also missing since it was demolished after Woodside School (current-day Rolland-Warner Middle School) opened in the 1960s. (Courtesy of Jan Reithel.)

The demolition of the Castle was the beginning of the end for the home. In 1976, Dr. David Ethridge became superintendent. He had already been involved in the closure of several other Michigan mental institutions. Immediately, Ethridge announced the transfer of 400 residents to other institutions or group homes and had plans to reduce the number of residents even more in the next 10 years. (Courtesy of the Ethridge family.)

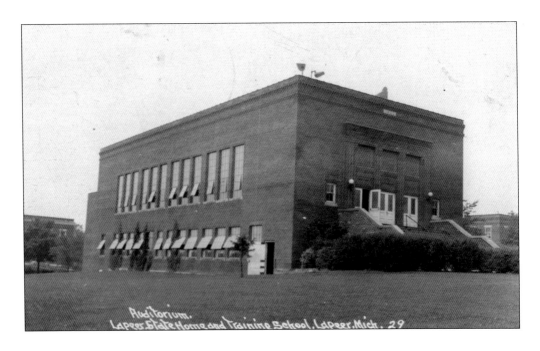

By July 1976, Ethridge had to deal with his first workers' picket line—it was not his last. The gymnasium was still in use at the time. Despite its age, it was in fair shape but no longer conformed to safety standards. Shown here is the gymnasium (or auditorium) when it was first built (above) and shortly before it was razed (below). It was located on the east side of Demille Road and on the south side of the railroad tracks. (Above, courtesy of the Mabery collection; below, Charlie Whipp.)

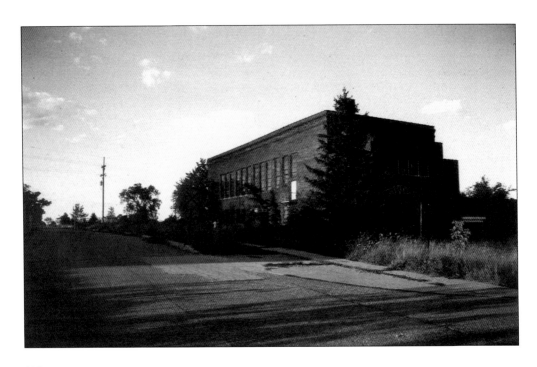

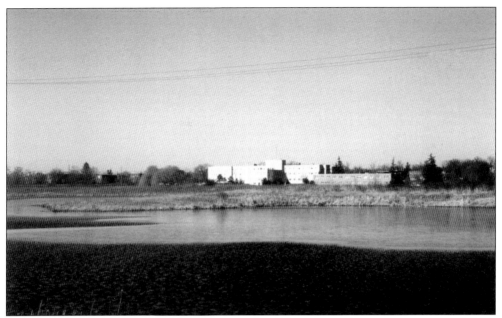

As Ethridge reduced the number of residents and staff, he instituted new patient care guidelines that were unpopular with staff. In November 1977, the staff of Building 10 was suspended for patient abuse, and three staff members were eventually fired. Turmoil at the home continued as more residents were transferred to group homes and more staff was laid off. Etheridge also started a new sex-education program for residents that caused quite a stir in the community but was eventually adopted by other institutions in the state. While there are numerous photographs of the main campus buildings, there are few images of the recreation area. These images are of Building 5 (below) in the recreation area on Farmers Creek just before it was demolished and the pond in the recreation area. (Both, courtesy of Charlie Whipp.)

By 1978, morale among the home staff was at an all-time low. A state study in 1978 reported that Oakdale was in a state of "armed truce" between staff members, unions, administration, and parents of residents. More picket lines were seen at the home in June 1978, even as a $2.5 million remodel was getting ready to get underway. Plans to remodel the home were met with opposition. In 1979, bad publicity continued for the home when a bus driver ran over a resident twice and a resident became pregnant while she was in the home's infirmary. As the home grew, building names were changed from letters to numbers. Each building had a number plate. This is from one of the men's cottages south of the railroad tracks and east of Demille Road. (Both, courtesy of Charlie Whipp.)

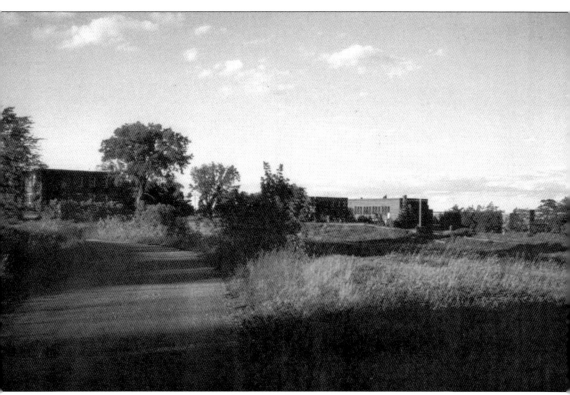

These men's cottages located south of the railroad tracks housed the residents "warehouse style," with 25 or more residents per room and no place to store personal effects. The infamous utility tunnels of Lapeer area urban myth that ran under the railroad tracks had deteriorated until the buildings could no longer be heated. Buildings 2, 3, 10, 11, and 12 are shown here. (Courtesy of Charlie Whipp.)

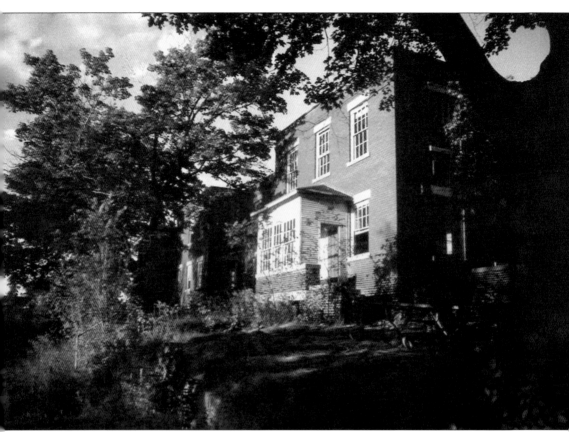
The buildings were abandoned in the 1980s as residents were transferred to newly remodeled cottages or group homes or placed in other communities or institutions. This photograph is of Building 2. (Courtesy of Charlie Whipp.)

Newly remodeled Building 45 housed 104 residents, with 16 residents each sharing a four-bedroom apartment. The apartments were furnished with large living rooms, dining areas, kitchens, and bathrooms. This was a departure from the old barrack-type dormitories and communal bathrooms. Each apartment also had a sundeck and was designed for the physically handicapped. The building also contained a lounge and kitchen for the staff, and the ratio of staff to resident was 1 to 6. It also had a physical-therapy and training room for all residents to use. The building was used to allow the remaining residents to get accustomed to apartment life so that they could be moved to group homes in the community. These photographs show the newly remodeled Building 45, now Mott Community College. (Above, courtesy of the *County Press*; below, the Ethridge family.)

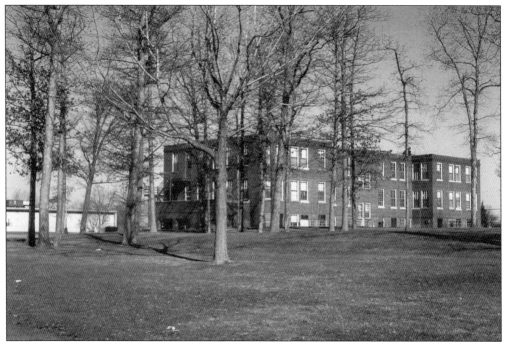

When the newly remodeled buildings opened, they set a higher standard in mental health care for other institutions to follow and helped get Oakdale certified. Building 32 was a women's cottage located on M-21 near present-day Rolland-Warner Middle School, seen in the background on the left. Buildings 30 and 55 (also near current-day Rolland-Warner) were a women's cottage and a women's hospital. None of these building were included in the remodel. (Both, courtesy of Charlie Whipp.)

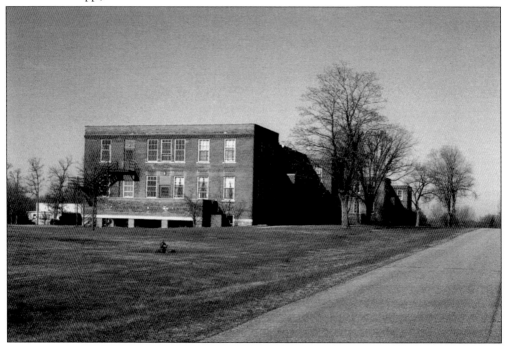

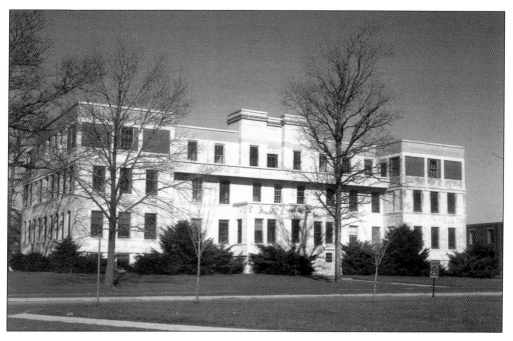

By 1980–1981, Buildings 45, 40, 33, and 34 were remodeled into apartment-style settings with only four residents to a room. The newer 80-bed hospital (Building 44) and behavioral unit for the "severely agitated" residents closed. The boys' hospital, pictured here and located on Demille Road on the northwest corner of the railroad tracks, was built before 1916 and was no longer in use by the 1970s. These photographs were taken before the boys' hospital was razed. (Both, courtesy of Charlie Whipp.)

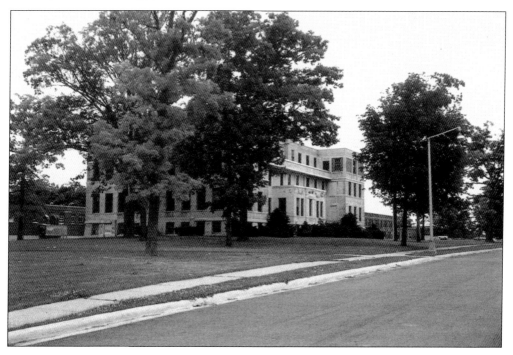

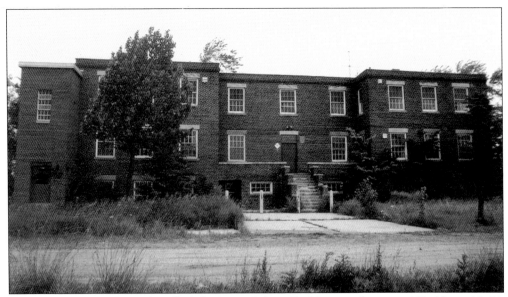

The men's housing, formerly called the Farm Colony Buildings and renamed Buildings 10, 11, and 12, were standing and in use until the 1980s, but structures were in too bad of shape to be remodeled. They were vacated as cottages north of the railroad tracks were remodeled early in the 1980s. These buildings were located south of the railroad tracks near the gymnasium. (Courtesy of Charlie Whipp.)

Despite the struggles at the beginning of Dr. Ethridge's tenure, for the first time in its history, the home was accredited by the Accreditation Council for Services for the Mentally Retarded and Other Developmentally Disabled Persons in 1984. It was not enough to save the home. The last of the residents were discharged on September 27, 1991. (Courtesy of the Ethridge family.)

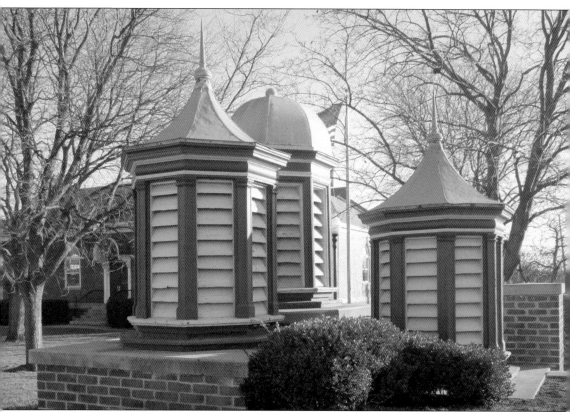

Only Buildings 45, 49, and 71 were repurposed. The remaining buildings (approximately 20) were razed by Diamond Demolition of Detroit in January 1997. Several ornamental copper and wooden cupolas were salvaged from the Lapeer State Home during the demolition and were added as decorations in various locations around the city of Lapeer, including these that were placed in front of the Marguerite deAngeli Branch Library. A drawing of the cupolas was also used as part of the design of the City of Lapeer's logo. (Courtesy of LDL.)

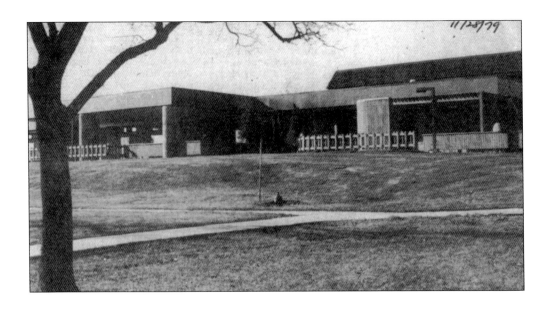

The nursery (Building 45) was constructed in 1962 and closed in 1992. It is shown today (below), long after it was remodeled in the late 1970s. It was leased from the City of Lapeer by Mott Community College in 1993. The Community Foundation of Greater Flint provided $178,000 to bring it up to code for students. Classes started with 905 students, eight classrooms, and a computer lab. (Above, courtesy of the *County Press*; below, LDL.)

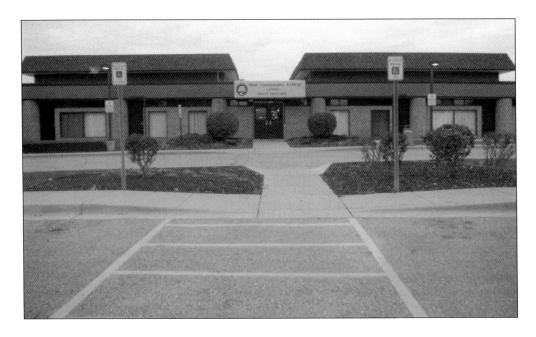

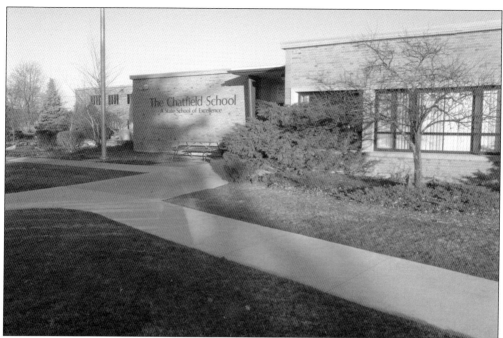

The administration building, known as Building 71, underwent a $1.3 million transformation to become Lapeer's only charter school, Chatfield. The dolphin statue at right was found during the demolition of the Lapeer State Home. It was saved and placed in the gardens at the front of the Chatfield Charter School in Lapeer as its mascot. (Both, courtesy of LDL.)

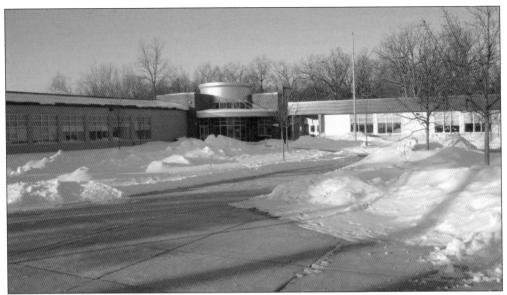

The home-training school, Building 49, became Woodside Alternative School. Newly remodeled in 2009, it reopened as Rolland-Warner Middle School (pictured). Even though it was extensively remodeled, several pieces of the original building still exist. (Courtesy of LDL.)

Little evidence remains of the home's existence. Satellite photographs of the grounds still show the remains of building foundations and roads. Odd pieces of buildings and development remnants like this old well or utility opening can still be found when exploring the old grounds. (Courtesy of LDL.)

The remaining grounds of the home became part of Prairies and Ponds at Oakdale through the efforts of the City of Lapeer Parks and Recreation and the Lapeer County Community Foundation. Farmers Creek at Oakdale is a part of Prairies and Ponds. Here, Farmers Creek continues to meander through the city of Lapeer as it did when the home was built. It is now accessible through developed paths and walkways. (Both, courtesy of LDL.)

The cemetery remains on the south side of the original property. Approximately 416 residents of the Lapeer State Home were buried there between 1905 and 1946. Most graves were given simple numbered brick markers, and many have sunken out of sight. If a resident's family were wealthy enough to purchase it, a headstone was placed. A document titled "Grave Registry: 15 Dec. 1971" was found in the home's maintenance building, listing names of those believed to be buried in the cemetery, including Lawrence Hekethorn (or Hekathron), whose funeral was handled by Brown Funeral Home and who was possibly the first resident buried there in October 1905. (Both, courtesy of LDL.)

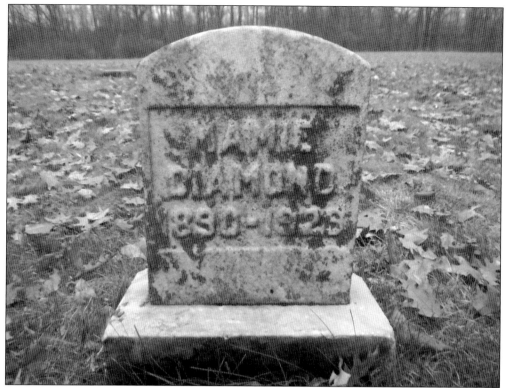

A list of those who are believed to be buried in the home's cemetery is housed at the Lapeer County Genealogical Society. The bodies of many of those who died at the home were donated to the University of Michigan Medical School in Ann Arbor for anatomical studies. A list of those whose bodies were donated is held at the Marguerite deAngeli Branch Library in Lapeer. (Both, courtesy of LDL.)

DISCOVER THOUSANDS OF LOCAL HISTORY BOOKS FEATURING MILLIONS OF VINTAGE IMAGES

Arcadia Publishing, the leading local history publisher in the United States, is committed to making history accessible and meaningful through publishing books that celebrate and preserve the heritage of America's people and places.

Find more books like this at
www.arcadiapublishing.com

Search for your hometown history, your old stomping grounds, and even your favorite sports team.

Consistent with our mission to preserve history on a local level, this book was printed in South Carolina on American-made paper and manufactured entirely in the United States. Products carrying the accredited Forest Stewardship Council (FSC) label are printed on 100 percent FSC-certified paper.